IMAGES
of America

FORT MILL

IMAGES
of America

FORT MILL

LeAnne Burnett Morse

ARCADIA
PUBLISHING

Published by Arcadia Publishing
Charleston, South Carolina

Printed in the United States of America

Library of Congress Control Number: 2014952757

For all general information, please contact Arcadia Publishing:
Telephone 843-853-2070
Fax 843-853-0044
E-mail sales@arcadiapublishing.com
For customer service and orders:
Toll-Free 1-888-313-2665

Visit us on the Internet at www.arcadiapublishing.com

*For my sons, Chase and Ethan, and the adopted hometown
where your childhood memories will always live*

CONTENTS

ACKNOWLEDGMENTS

Writing a book about a town with a nearly 400-year history is a task that is not accomplished by a single person. The photographs and stories have come from the collections and memories of generous people whose personal ties to Fort Mill go back much further than my own. I am grateful to Kira Ferris and the Fort Mill History Museum, Mary Mallaney and the York County Public Library, Billie Anne McKellar and the Catawba Cultural Center, Michael Harrison and the *Fort Mill Times*, Melissa White, John Spratt, Betty Mills Thomas, Ken Dixon, Rudy Sanders, Tommy Merritt, Elizabeth Ford, Mary Sue Wolfe, Cora Lyles, Elizabeth Patterson White, Jason Ford, Carol Dixon, Jim Ardrey, Josh Herbert, the works of Louise Pettus and William Bradford, and all who have combed through family treasures to share evidence of days gone by. Special recognition is due Ann Evans and the Springs Close Family Archives. Ann hosted me many times at the White Homestead and allowed me to pour through that vast collection that holds enough treasures for a dozen books. She patiently answered my questions and never once hung up the phone when I asked for a particular item that was the equivalent of a needle in a haystack. "Let me check," she would say. And usually she could find it. There would be no book without Ann. I owe many thanks to my editor at Arcadia Publishing, Jesse Darland, and to my husband, Kelly, who has patiently read everything I have written for 20 years. *Everything.* And finally, to answer the question posed to me often when locals learned I was working on a book about Fort Mill, though I grew up 500 miles away in Kentucky (a *border state*, a condition for which I will always be considered a quasi-Yankee in these parts). "What made you want to write a book about Fort Mill?" they asked. To answer that I point to my parents, Joe Frank and Jane Burnett, who taught me to love history. To truly love a place one has to know its history, and I do truly love this place.

INTRODUCTION

Four hundred years ago, when panthers and deer roamed the local river valley and before the Carolina colony had even been established, a scouting party for the Catawba Indians examined the area that would eventually become Fort Mill and declared it a viable option for their new home. A part of the larger Sioux Nation, the Catawba had been living in Canada for generations, but the harsh winters and diminished game reserves forced them to seek a more plentiful and salubrious environment or face hardship and starvation. Around 1600, one of three scouting parties that had been sent to various regions of the continent returned and told of a fertile valley and navigable river with plenty of forest and gently rolling hills. Hunting, fishing, and crop cultivation could flourish in this place, and the winters were mild in comparison to the brutal Canadian weather. More than 12,000 members of the tribe embarked on a 1,500-mile journey south. It would take them two long years of struggle to arrive in the valley they would call home. Along the way, they were harassed by hostile Indian tribes and confronted daily with the logistical difficulties of moving such a vast population over a long distance. Even when they arrived and began to establish their new home, tribes like the Cherokee, Waxhaw, and the aggressive Shawnee continued to attack and harass them in an effort to force them from the land they had so diligently sought. They also saw their numbers diminished greatly by the ravages of smallpox. This "white man's disease" decimated the tribe and reduced their number to only 3,000 warriors. The Catawba might have become insular and rejected any outsiders who would tread upon their new property, but that was not the way of the tribe.

During this time, the colony of Carolina had been established and then split into north and south in 1712. Around 1755, Thomas Spratt departed his father's home in nearby Charlotte, North Carolina. The Spratt family had immigrated to the new world from Ireland, living first in Philadelphia, Pennsylvania, and eventually making their way south to settle in Charlotte. It is believed that Thomas Spratt was born at sea on the crossing from Ireland. When he left his father's home in 1755 with his wife, Elizabeth, he was en route to Long Cane Creek, a community of Scots-Irish Presbyterians near present-day Abbeville, South Carolina. When the Spratts arrived at the Nation Ford, they decided to make camp near the river. This fortuitous decision had consequences that stretch to this day, as it was here the Spratts encountered the Catawba, and the seeds of an unlikely alliance were sown. Spratt had considerable farming knowledge and expertise, and the Catawba were expert traders. The two groups helped each other and became friends. The Spratts were encouraged to stay longer in the area, and they never resumed their journey to Long Cane Creek. The Catawba eventually offered a portion of land to the Spratts for settlement. The grant, 4,535 acres, was to be settled by families handpicked by the Spratts. It was part of a 144,000-acre land grant that had been given to the Catawba after the French and Indian War. The Spratts were to be the equivalent of modern-day real estate brokers, bringing settlers to the area who could help set up farms and businesses so the region could thrive economically, as well as socially. The settlers would help protect the Catawba from neighboring tribes, and the Catawba would aid the settlers in trade and protection as well.

New families began arriving with names that still dot the census records of the area today: White, Merritt, Garrison, Elliott, and more. Thomas Spratt was so beloved by the Catawba that they gave him a tribal name, Kanawha. The name was taken from a river of the same name in West Virginia. Spratt fought alongside the Catawba as they battled other tribes near the Kanawha River, and they bestowed the name upon him as a sign of friendship and solidarity.

As colonists saw their numbers divided over the issue of independence in the 1770s, British forces made their way through the Carolinas. Gen. Lord Charles Cornwallis commanded the forces stationed in the Southern states as they attempted to subdue rebellion against the Crown. He was accompanied by his most infamous subordinate officer, Lt. Col. Banastre Tarleton, who was widely known for his cruelty and harsh tactics. The duo saw action in South Carolina at the British defeat of Continental forces at Camden, but it was the unofficial skirmishes with militia units that would frustrate and thwart the plans of Cornwallis on his journey north. Around 1780, the general bivouacked his forces in the Fort Mill area. During the time he spent here and in nearby Charlotte, he reportedly recorded in his journal his thoughts about the militia he regarded as nothing more than rabble. His comments included the notion that fighting these militiamen was like "stirring up a hornet's nest." The characterization stuck, and today the professional basketball team in Charlotte carries the name Hornets as a reminder of the tenacity and fighting spirit of the first patriots of this area.

The new settlement that crept up near the Catawba River came to be known as Little York, and evidence of a thriving village began to appear. Plans were made to set up a gristmill, and the settlers also needed a place of worship to call their own. In 1788, Unity Presbyterian Church was established in a log cabin near present-day Marshall Street. The new settlers were Scots-Irish Presbyterians whose loyalties stretched back to both the House of York and the House of Lancaster. The two groups were historically at odds, so they chose the name Unity to signal their desire to leave old grudges in the past and start fresh in this new place. The old cemetery at Unity still exists at the corner of Marshall and Unity Streets, but the church eventually moved to its current location on Tom Hall Street, where its fourth (now called the historic sanctuary) and fifth sanctuary now stand. The first three buildings are no longer in existence, but this first congregation of the new town thrives to this day. Eventually, a post office was added in 1820, and the region saw its economic fortunes tied to "King Cotton" and the means of moving it to market in the form of the new railroad, which arrived in town in 1852. By this time, the area had long been known as Fort Mill, but it was still not incorporated officially.

Less than a decade after the first train was heard rumbling through downtown, Fort Mill found itself a part of the first state to declare its ties to the United States null and void. When South Carolina seceded from the Union on December 20, 1860, the town braced itself for upheaval, as the threat of war loomed. After the attack on Fort Sumter in April 1861, volunteers donned the gray and went to war for four long years. While the soldiers fought, the women and children left behind faced the hardships that war always brings to the door of those in its path, including scarcity of food and essential items as well as a shortage of labor to plant and harvest crops and manage farms. Solomon Spratt was a slave on the plantation of Thomas Dryden Spratt. He was well regarded in the area and reported to be considered part of the family. In the absence of the white men of the area, Solomon Spratt took it upon himself to organize a group of fellow slaves to help struggling families by taking care of their crops, seeing to food distribution to those in need, and providing the necessary labor to keep farms and businesses running. When the soldiers returned from the war, they were surprised and humbled by how the slaves had cared for their families. Samuel E. White and John McKee Spratt led the effort to erect a monument in newly dedicated Confederate Park to honor the efforts of these selfless men, who had ensured the survival of their loved ones in a time of peril. Three other monuments were also added to the park, recognizing the contributions of the soldiers, the women of the area, and the Catawba. Confederate Park remains a place of quiet repose anchoring Main Street today.

Tiny Fort Mill took its place in the history of the final days of the Confederacy, when Pres. Jefferson Davis and his cabinet were in the midst of their harried flight from Richmond, Virginia,

as the city was on the verge of falling into Union hands. As the men made their way south, they stopped in Fort Mill and spent the night at Springfield Plantation as guests of owner and signer of the Ordinance of Secession Andrew Baxter Springs. Springs recommended they disband and travel separately, thereby making it less likely they would be captured by Union troops. The following day, the cabinet met for the final time at nearby White Homestead. The Confederacy was no more, but Fort Mill was just beginning to recognize its own potential.

As the Civil War receded into memory, the town of Fort Mill made itself official with incorporation on February 13, 1873. B.F. Powell was elected as the town's first mayor, but he bore the title "intendant."

Though the name Fort Mill is a reference to the original gristmill, many believe it refers to the textile mill industry that began here when Samuel E. White chartered the Fort Mill Manufacturing Company in January 1887. The company would grow to include several mills, two of which were located in Fort Mill. Eventually, under the leadership of White's grandson Elliott White Springs, the company would be renamed Springs Cotton Mills and, later, Springs Industries. In 1947, the company created the Springmaid brand of linens, and this name became a household word. Elliott White Springs, known about town as "the Colonel," was a decorated World War I fighter pilot before he became president of the manufacturing company. He displayed a keen business acumen and an even greater sense of responsibility and fairness for the people who worked for him. During the Depression, he kept the mills running and stockpiled the goods in warehouses, even though he had no buyers for them. This turned out to be a fortuitous decision, as the demand for such goods with the outbreak of World War II was a boon for business. He devoted much time and a great deal of resources to making sure his employees had adequate housing, health care, and recreational opportunities. The Springs family businesses diversified into the areas of financial, agricultural, philanthropic, and preservation interests, and they continue to positively impact both the people and the economy of Fort Mill and the region.

Fort is a reference to a proposed fort that was commissioned in 1756 by the colonial governor of North Carolina. A structure was erected at Fort Dobbs in Statesville, North Carolina, and funds were made available for a second fort in the Fort Mill area as a means of protection for the Catawba. At the time, the dividing line between North and South Carolina was unclear in this geographic area. (Some say the reason for the meandering line could be traced to early surveyors abandoning their westward progress for a jaunt slightly north to obtain whiskey.) This area was generally accepted as part of North Carolina before the boundary line was formally solidified. The Catawba Indians had requested their land remain under the jurisdiction of South Carolina, and this request was ultimately honored, though details are unclear. Either way, the local fort was never built. There is some evidence of a well and trenches on the property, but no structure was completed. Still, the proposed fort had an impact on the area that remains with the town today in its name.

The town found itself on the leading edge of innovation around 1900, when a corporation was formed to build a dam and plant to generate electricity. Fort Mill was among the first towns to receive electrical power by contract from the new Catawba Power Company. Previous operations in town had been powered by steam. This small company with its operation on the Catawba River formed the nucleus for modern industry leader Duke Energy.

Fort Mill marched headlong into the 20th century with a thriving downtown business area and a burgeoning textile industry. The Industrial Revolution had changed the face of the American economy, and the need for workers to be skilled and educated was more important than ever. Schools for boys and girls were opening, and students were staying in school beyond just the initial grades in which they learned reading and arithmetic. A broader curriculum came into vogue, and schools in Fort Mill rose early to meet the challenge. Fort Mill Academy was constructed around 1870 as a private preparatory school where students could board for about $9 per month, and tuition for a 20-week session of courses to include Latin and Greek cost $20. The school was led by Prof. A.R. Banks, who began work in January 1871. Eventually, the academy became a public school. In the early 1920s, a Fort Mill Manufacturing employee from England named George

Fish noticed that schools for black children were not up to par with those for white children. He proposed a school of equal quality for them, and the school was named in his honor when it opened in 1924. On the day the George Fish School opened, students marched from the old academy, which had been passed down to them when a new public school had been built for the white children, all the way to the steps of the new school on Steele Street. For the first time, these students had something brand new that was all their own, and generations of African American scholars rose from the rolls of the George Fish School. The school became the social anchor for the local African American community known as Paradise. Many of the students would come of age during the era of the civil rights movement. Their efforts and commitment to maintaining the quality and dignity of their community was the basis for integration and acceptance that is enjoyed fully today by people from all walks of life who make their homes in Fort Mill.

Quality education is a top town priority in the 21st century, with Fort Mill District Four schools ranking among the highest in quality in the state, and students from the district perform well above average on standardized tests and college entrance exams. Within the school system, a focus has traditionally been made on excellence both in and out of the classroom, with athletic teams performing well on fields and courts of various sports at the state level and groups like the high school academic teams garnering success in the competitive arena. The arts have also been a longtime priority. In addition to theatrical and dance performances, symphonic and jazz ensembles, and a commitment to art recognized with a yearly community festival, the area boasts the most honored high school marching band in the state's history. The Fort Mill High School Marching Band has won 24 state titles in various classes since 1976 and represented South Carolina and the United States in national and international venues.

Since 2000, Fort Mill has experienced an astronomical 42-percent population growth. The sleepy, self-contained village has become a rapidly expanding bedroom community for workers in adjacent Charlotte and Rock Hill. But the town has not lost its unique identity or been swallowed up by the personalities of the larger cities that surround it. The same pioneer spirit and commitment to community that first emerged in Little York continues to thrive with the arrival of new settlers from around the world in present-day Fort Mill.

One

PRELUDE TO TOWNSHIP
A MEETING AT THE NATION FORD

Before there was a bandstand at Confederate Park, a peach orchard encompassing thousands of acres, or a mill producing linens sold the world over, there was a place called Little York. It was a settlement of Scots-Irish Presbyterian immigrants who put up a gristmill and a church and got to the business of carving out a town from a river valley. But they were not the first. Before Little York was home to colonists from across the ocean, it was home to the Catawba Indians. This tribe, part of the Sioux Nation, had chosen the land on the banks of the Catawba River when their previous settlement in Canada proved unable to support their needs due to the harsh winters and dwindling herds of wild game. Since the early 1600s, they had lived well in the fertile valley. A peaceful people, they often had to defend themselves from neighboring tribes of Waxhaw and Shawnee. They also faced the dreaded disease of the white man—smallpox. From the original 12,000 who left Canada bound for Carolina, their numbers had been reduced to only 3,000 warriors by 1760.

Around this time, Thomas Spratt and his wife, Elizabeth, left nearby Charlotte, North Carolina, en route to Long Cane Creek, where they planned to live. On their journey, they camped near the Nation Ford and encountered the Catawba people. The two groups were able to share observations about hunting and farming, each discovering an appreciation for the knowledge of the other. Soon after, the natives offered the Spratts a 4,535-acre tract of land and asked them to stay. More settlers followed, with names that are still on community rolls today, like Elliott, White, and Merritt. The community grew and thrived, maintaining its unique character even with the influence of its more populous neighbors, Charlotte and Rock Hill. Ultimately, the area that had shown such promise to the Catawba people and European settlers alike came into its own and was incorporated as Fort Mill Township in 1873.

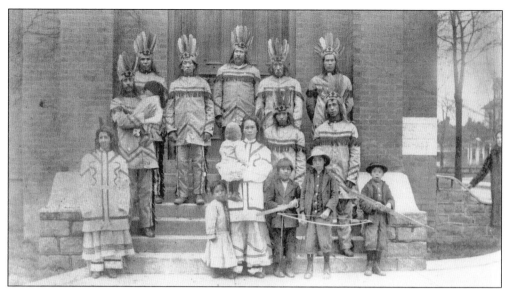

Catawba Indians attend the Corn Exposition in Rock Hill, South Carolina, in 1913. The Catawba people welcomed the Thomas Spratt family in the 1750s and offered the family a tract of land, which would later become the town of Fort Mill. Today, the Catawba Indian Nation is the only tribe to be officially recognized by South Carolina. (Courtesy of Catawba Cultural Center Archives.)

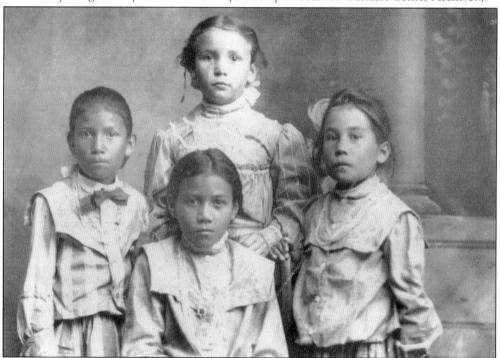

At a time when Indian children were not permitted to attend local schools, Catawba families often sent their children away to be educated. Pictured here from left to right are Artemis Harris, Mary Ayers, Lavinia Harris, and Edith Harris (seated), who attended the Carlisle Indian Industrial School in Carlisle, Pennsylvania, from 1904 to 1909. (Courtesy of Catawba Cultural Center Archives.)

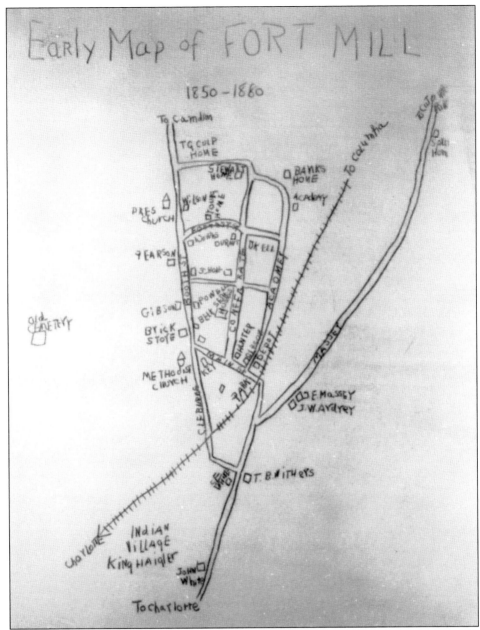

This hand-drawn map of early Fort Mill shows the town during the time period from 1850 to 1880. The names of most streets are recognizable today, including Confederate, Academy, and Clebourne Streets. Present-day Tom Hall Street was named Booth during this period. The street was renamed for Medal of Honor recipient Thomas Lee Hall, a member of Company G who was killed in France during World War I. The Clebourne Street area was home to an African American community called Maybee Hollow prior to the development of the Paradise community. Another African American enclave was located near the train tracks in an area called Railroad Row. In addition to businesses on Main Street, many of the founding families of the town maintained homes on adjacent streets such as Confederate and Academy. Homes and churches are labeled, as well as the railroad tracks and the Indian village. (Courtesy of Fort Mill History Museum.)

Thomas B. Spratt is shown here with two of his children, John McKee Spratt (standing) and Thomas B. Spratt Jr., in 1909. The elder Spratt served in World War I, earning the rank of lieutenant colonel. He and his wife, Eleanor Harris, had five children. (Courtesy of Fort Mill History Museum.)

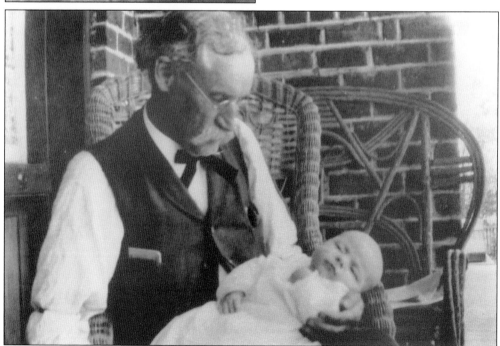

John McKee Spratt poses with his grandson and namesake John McKee Spratt II about 1907. John McKee Spratt Sr. was a descendant of founding settler Thomas Spratt, and he and Samuel E. White were instrumental in the development of Confederate Park. His great-grandson John McKee Spratt III served the area in the US Congress for 28 years. (Courtesy of the Springs Close Family Archives.)

During the American Revolution, British troops under the command of Gen. Lord Charles Cornwallis camped in this wooded area just outside of Fort Mill. He was accompanied by his most infamous subordinate officer, Lt. Col. Banastre Tarleton, who was widely known for his cruelty and harsh tactics. They were attempting to move their troops north after the famous British defeat of Continental forces at Camden, South Carolina, but encountered significant resistance in the area around Fort Mill and Charlotte, North Carolina. The general was a known diarist, and legend has it that his diary entries of this period recorded the difficulty he encountered when facing local militia. He likened it to "stirring up a hornet's nest." The name stuck, and the NBA team in adjacent Charlotte carries the name Hornets in recognition of the tenacity and fighting spirit of area citizenry. (Courtesy of Fort Mill History Museum.)

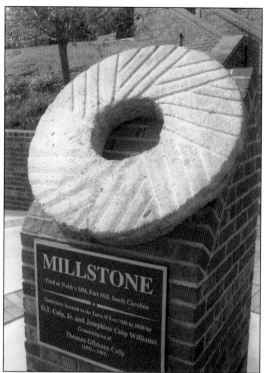

This granite millstone is from the original gristmill that inspired the town's name. Called Webb's Mill, it operated from the 1770s until the 1880s. This stone, used for grinding corn and wheat, anchors Millstone Park at the foot of Main Street and is one of only three that remain from the mill. (Courtesy of LeAnne Burnett Morse.)

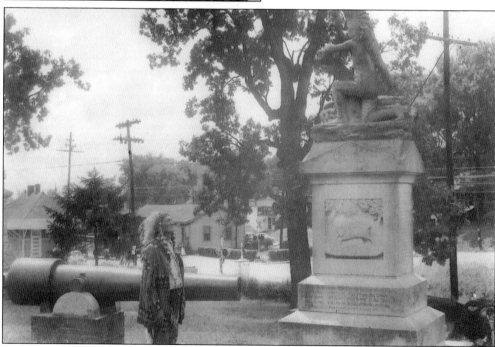

Chief Samuel Taylor Blue examines the Catawba monument in Confederate Park in the 1950s. Blue was chief of the Catawba tribe from 1928 to 1939 and again in the late 1950s. He was a vocal proponent of government recognition of the rights of the tribe and one of the last known speakers of the Catawba language. (Courtesy of Tommy Merritt.)

Two

PROSPERITY IN THE PIEDMONT
COMMERCE AND THE RISE OF THE MILLS

Situated between larger cities Charlotte, North Carolina, and Rock Hill, South Carolina, Fort Mill could have developed as little more than a place to rest one's head at the end of a long day with business and commerce reserved for the cities, but that was not the way of it. From the early days, Fort Mill was a self-sufficient town with everything one would need to run a home and a business. Longtime residents remember fondly the heyday of Main Street, when merchants were busy servicing customers, hotels were filled with travelers stepping off the Southern Railroad trains at the depot, and community enclaves had unique identities. Be it general stores, cotton farms, or manufacturing centers, there was plenty of commerce in action. With the increased prevalence of automobile and air travel, the town lost some of its central focus, as most small towns have. But when iron horses thundered through town daily and business was done in person with a handshake, Fort Mill thrived and prospered despite war and economic turmoil outside its borders.

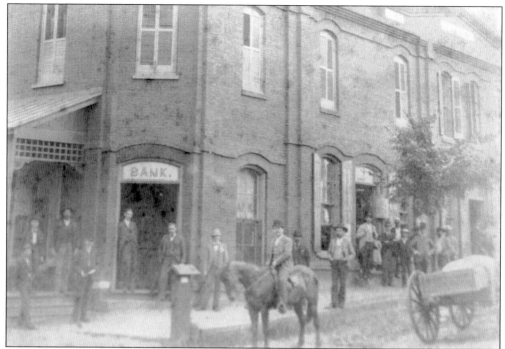

Townspeople pose for a photograph in front of town hall and the whittling porch in the late 19th century. The bank was in the same building, and a bell was located on top of town hall to summon help in case of fire. Ironically, the building burned many years later, and a vacant lot next to Confederate Park remains. (Courtesy of the Springs Close Family Archives.)

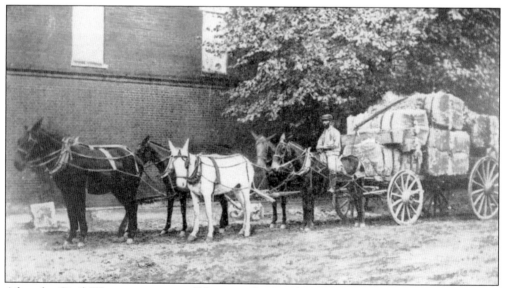

After the Civil War, cotton was still king in the South, and getting it from field to market remained a laborious process. This photograph shows a wagon loaded with bales making its way along unpaved roads to the next step in its journey from seed to cloth. (Courtesy of the Springs Close Family Archives.)

In 1905, awnings are extended to protect fresh produce in the windows of A.O. Jones's grocery store on Main Street. Carothers's barbershop is to the right. The stacked stones of the rock wall along the street's edge predate the modern concrete and steel railings that exist today. (Courtesy of the Springs Close Family Archive.)

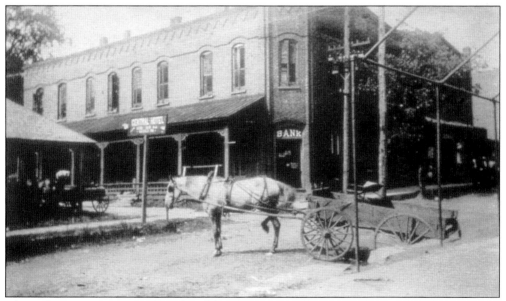

The A.O. Jones Grocery and Market delivery wagon pulled by Old George was a familiar sight downtown in the early part of the 20th century. The bandstand at Confederate Park and the whittling porch are visible in this shot of lower Main Street in 1912. (Courtesy of the J.B. Mills Collection and Betty Mills Thomas.)

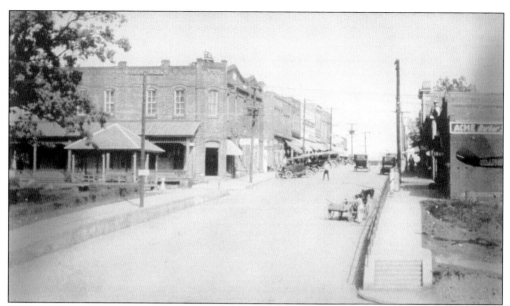

William Perry stands alongside his wagon on Main Street in 1914. The Acme barbershop is visible at right. The shop was owned and operated by N.L. Carothers. Town hall with its fire bell on top and the whittling porch can be seen at left with Confederate Park's bandstand in the foreground. Note the presence of automobiles lining the street along with Perry's wagon. (Courtesy of Fort Mill History Museum.)

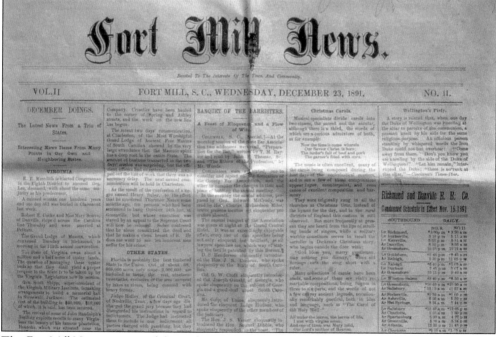

The *Fort Mill News* was one of the early newspapers to serve the area. This photograph is of the front page on December 23, 1892. W.B. Ardrey Sr. was publisher of the paper and later sold it to W.R. Bradford Sr. The newspaper eventually became the *Fort Mill Times*. The *Times* continues to serve the area today. (Courtesy of the J.B. Mills Collection and Betty Mills Thomas.)

Citizens of Fort Mill enjoyed early access to electrical power. As one of the first towns to receive service from the Catawba Power Company, lights burned throughout the town, powered by current from this distribution station, pictured here in 1904. Catawba Power Company went on to become energy giant Duke Energy. (Courtesy of the J.B. Mills Collection and Betty Mills Thomas.)

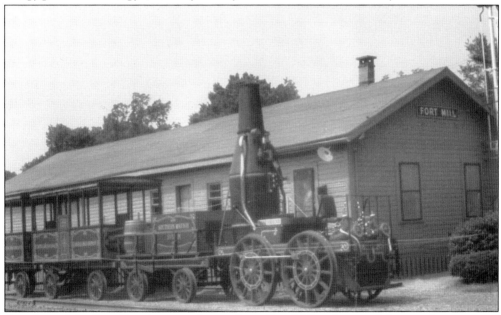

A replica of the *Best Friend* sits on the tracks in Fort Mill in honor of the town's centennial celebration in July 1973. On Christmas Day 1830, the locomotive was the first steam-powered engine to run on the newly built railroad in Charleston, South Carolina. It achieved the spectacular speed of 25 miles per hour, thrilling passengers and investors alike. (Courtesy of the J.B. Mills Collection and Betty Mills Thomas.)

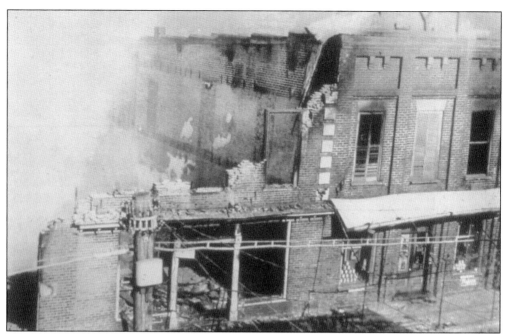

In 1914, fire broke out on Main Street, destroying several of the businesses on the north side of the street. The Meacham and Epps, L.J. Massey, and Mills and Young structures were lost, and six other businesses had significant damage. This was the third fire on Main Street in 26 years. (Courtesy of the J.B. Mills Collection and Betty Mills Thomas.)

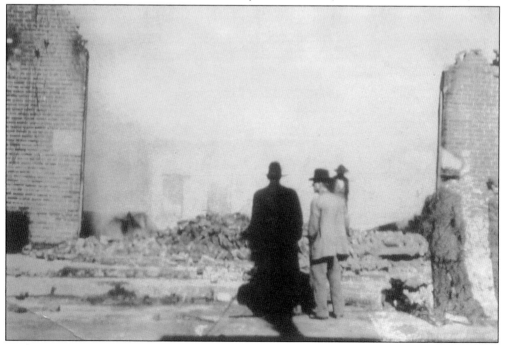

With the smoke cleared, the damage from the 1914 fire becomes clear to area residents. The third such fire to strike the downtown area in fewer than 30 years resulted in changes to firefighting practices. (Courtesy of the J.B. Mills Collection and Betty Mills Thomas.)

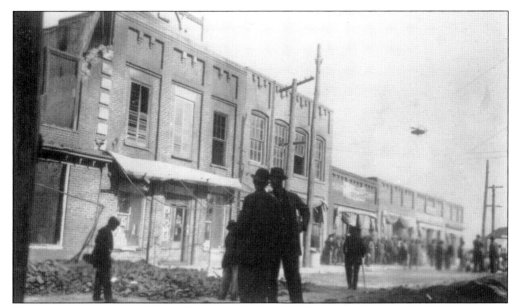

Townspeople survey rebuilding efforts after the fire of 1914 destroyed a great deal of the property on the north side of Main Street. In 1888, the same side of the street was nearly destroyed by fire, and six years later, the south side suffered extensive damage from yet another blaze. After the 1914 fire, a water pump was located on the street. (Courtesy of the Springs Close Family Archives.)

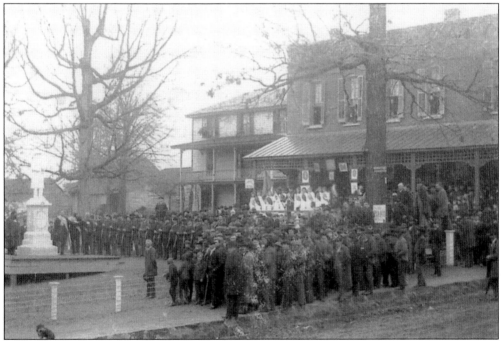

A large crowd gathers for the dedication of Confederate Park in 1891. Confederate veteran and Fort Mill Manufacturing founder Samuel Elliott White spearheaded development and financing of the park and arranged for the four monuments to various groups active in the war effort. The dais (left) surrounds the Confederate soldier monument, which was dedicated the same day. (Courtesy of Tommy Merritt.)

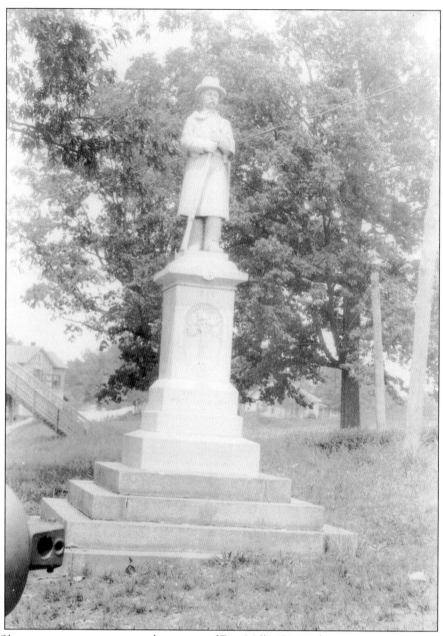

In 1891, a statue to commemorate the service of Fort Mill's 170 Civil War veterans was dedicated in Confederate Park. The statue depicts a Confederate soldier in full dress uniform with his rifle resting beside him atop a granite pedestal. Along with the names of each serviceman, the statue also includes the phrase "Defenders of State Sovereignty," as well as an image of a palmetto tree and the South Carolina motto, *Dum Spiro Spero*. The motto translates to "While I breathe, I hope." Samuel E. White, a Confederate veteran, donated the land for the park and purchased this first of four monuments to be erected in honor of various groups who supported the war effort. He arranged for the other three monuments to be funded with money raised from local citizens, feeling it would allow them a greater sense of ownership and connection. He later gave the park to the people of Fort Mill. (Courtesy of the Springs Close Family Archives.)

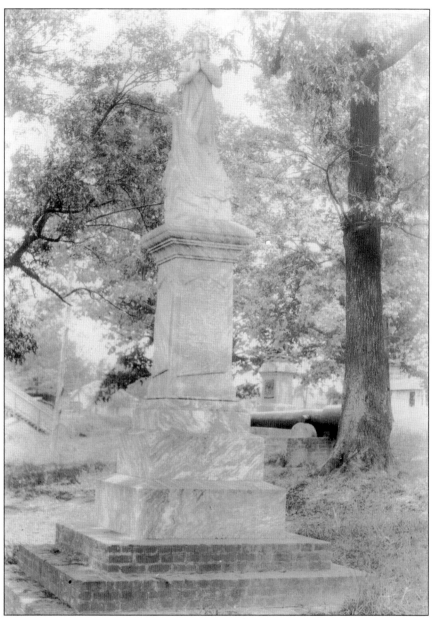

Four years after the dedication of the Confederate soldier monument, on May 21, 1895, a second monument was added to the park to honor the women of the Confederacy. One side of the statue bears the inscription "Affectionately dedicated by the Jefferson Davis Memorial Association to the women of the Confederacy, the living and the dead, who midst the gloom of war were heroines in the strife to perpetuate their noble sacrifices on the altar of our common country. Let sweet incense forever rise, till it reach them, 'in robes of victory beyond the skies.'" The names of Fort Mill women are listed on the side of the monument, though it is not a comprehensive list. Many women suffered in the service of the Confederacy, both during and after the war, as the South soldiered through hardship, deprivation, and the difficulties of Reconstruction. This monument was an effort to recognize the service of those whose front lines were not on distant battlefields but beside their own hearths. (Courtesy of the Springs Close Family Archives.)

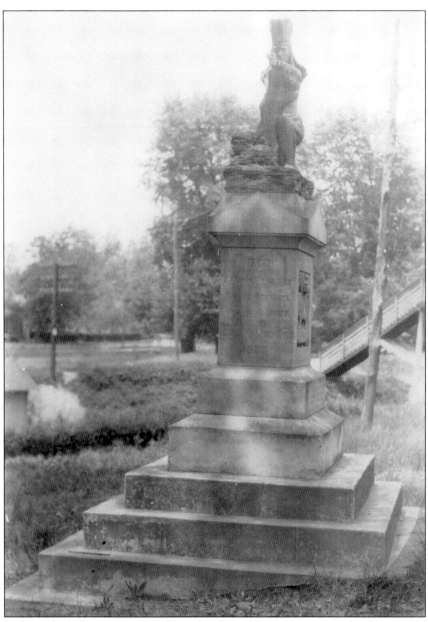

Since the Catawba Indians' arrival in the early 1600s, they were active in the defense of the Fort Mill area. This monument recognizing their Civil War service was erected by Samuel Elliott White and John McKee Spratt, the latter a descendant of Thomas Spratt, who was given the initial land grant that became Fort Mill by tribal elders. Thomas Spratt had been a valuable friend and ally to the Catawba, and they had honored him with a tribal name, Kanawha. He was given the name after he fought alongside them in battles with other tribes in West Virginia. His service in their defense was not forgotten, and they provided support when the local settlers were threatened, beginning during the American Revolution at nearby Brattonsville and farther afield at Hanging Rock and Kings Mountain. Their aid continued during the War Between the States, as 17 members of the tribe joined the Confederate army. This monument honors their service and was dedicated in 1900. (Courtesy of the Springs Close Family Archives.)

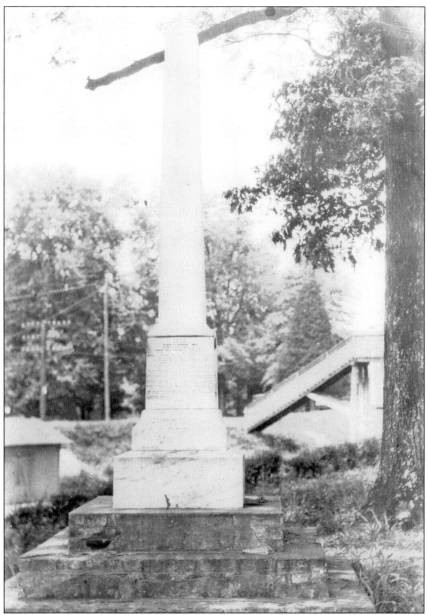

This obelisk is often referred to as the "Faithful Slaves" monument. While soldiers were away during the war, women and children faced difficulty keeping their farms running and scarcity of food and necessities. Area slaves, led by Solomon Spratt, took responsibility for helping those left behind. They helped with planting and harvesting crops, distributing food supplies, and providing labor where it was needed. Their actions kept many families from starvation and ruin, and soldiers returned to well tended homes and farms. An inscription reads "Dedicated to the faithful slaves who, loyal to a sacred trust, toiled for the support of the army, with matchless devotion, and with sterling fidelity guarded our defenseless homes, women and children during the struggle for the principles of our Confederate States of America." The monument was dedicated in 1895, thirty years after the end of the War Between the States. (Courtesy of the Springs Close Family Archives.)

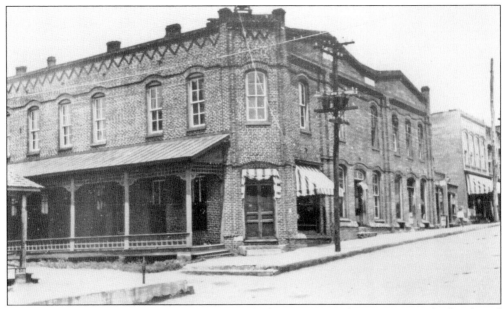

The original town hall featured a covered porch that was a popular resting area for locals and hotel guests alike. It was known colloquially as the whittling porch, where men would gather to whittle away the hours. Eventually, officials recommended the construction of the bandstand in the park as an alternative location for respite, as the porch was constantly littered with wood shavings. (Courtesy of the Springs Close Family Archives.)

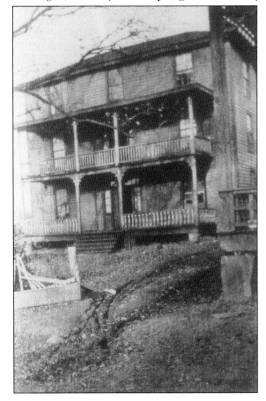

The Central Hotel was a home away from home for travelers arriving on the Southern Railroad. It was an easy walk from the depot, and the adjacent Confederate Park provided green space for guests to take the air. The hotel dates to 1875 and stood on the site until its demolition in 1947. (Courtesy of the J.B. Mills Collection and Betty Mills Thomas.)

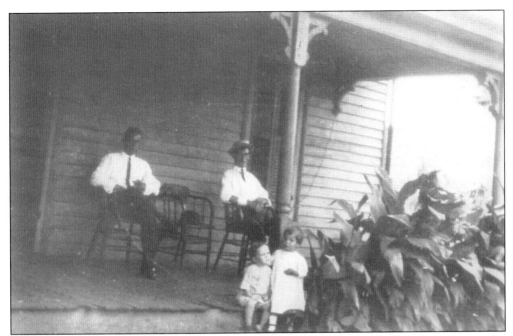

The Central Hotel was not the only place guests to Fort Mill could find a clean room and a hospitable welcome. The Palmetto Hotel was located on Confederate Street, about two blocks from the train depot. Guests to the hotel are seen here relaxing on the front porch. (Courtesy of the J.B. Mills Collection and Betty Mills Thomas.)

Fort Mill had its own social register of sorts for a time. The *Social Push* reported the doings of the town's movers and shakers. It was published for five months and made available in subscription form for $1 per year or 10¢ per month. John E. Ardrey was the owner and editor of the paper. (Courtesy of the J.B. Mills Collection and Betty Mills Thomas.)

The Social Push.

Our Motto: "Get in the Push."

Vol. I. FORT MILL, S. C., June 21, 1898. No. 1.

Social Events.

On last Monday evening our young men awoke from their long slumber and decided to take advantage of the beautiful moonlight by spending the evening on the banks of the Majestic Catawba. The party consisting of about twenty young people left town about 7 o'clock and on account of an "unforeseen accident" on the part of the charming chaperone did not return until the "wee small hours". After the party had crossed the river and amused themselves gathering ferns and strolling about for an hour or more, a most delicious lunch was served. All things passed off very nicely until it was time to return home. The party having gathered and as the boat was moving from the shore, it was discovered by someone that our charming chaperone and one of our prominent young business men were missing. A diligent search of an hour or more was made but all in vain. However, as the search was about to be given up the missing couple came strolling down the road and the blushes on our dear chaperone's cheeks told more plainly than words the same sweet story of old. Among the party were Misses Mabel and Mary Ardrey, Mamie Meacham, Effie Culp, Wrennie Harris, Zizs Young, Annie Young Mary Mack and Mary Belk. Messrs.

Miss Clara Sledge is at home from Winthrop.

Miss Roberta Thornwell will likely spend the summer near Asheville.

Miss Mary Sledge is visiting relatives in Steel Creek.

Miss Julia Thornwell has been visiting the Misses Parish in Yorkville this week.

Misses Fannie and Laura Parish are expected over from Yorkville this week to visit at Dr. Thornwell's

Wake up, boys! Summer passing away and only one straw-ride! What does all this mean?

What about a picnic on the river Friday night? There are a great many visiting ladies in town.

Miss Mary Thornwell and Prof. E. E. Thornwell are at home from Mayesville where they have been teaching school for the past 9 months.

Misses Nellie and Bessie Rankin gladdened the hearts of many friends here by coming down from Mt. Holly Saturday to spend several weeks. They are now at Mr. Fred Nims'.

Quite a number of our young people had made arrangements to join the young people of Rock Hill in a big moonlight picnic on last Monday night at the Jones' place on the other

29

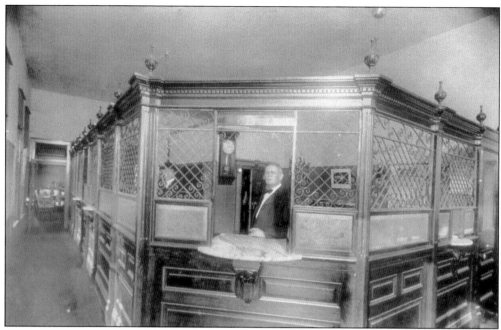

In 1914, cashier W.B. Meacham Sr. stands at the teller's window with a sack of pennies at the Savings Bank of Fort Mill. He offered to let a local four-year-old boy, J.B. Mills, keep the pennies if he could carry them home without putting the sack down. In later years, Mills recalled he only made it to the Palmetto Hotel down the street before having to return the pennies because they were too heavy. The bank encouraged citizens to entrust their money to the savings bank and earn a return of interest, a risky concept to people accustomed to keeping their earnings in coffee cans and under mattresses. A 1902 financial statement for the bank (left) showed it had assets on deposit of $25,500. (Both, courtesy of the J.B. Mills Collection and Betty Mills Thomas.)

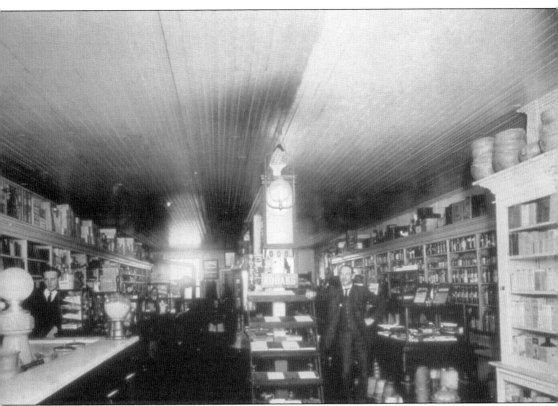

Ardrey's Drug Store was a fixture on Main Street. Proprietor W.B. Ardrey Sr. is shown in the center of this photograph, taken in 1912. The interior was lit with carbide lights, and the well stocked shelves to the right are topped with one of Ardrey's specialty items, Indian pottery. Ardrey's grandson Jim Ardrey tells a story his grandfather passed on to him about the day a salesman, known at the time as a drummer, came into the store selling a new kind of syrup. He offered Ardrey the opportunity to buy stock in the new brand, but he politely declined, saying "You'll never make any money with that." It turned out the syrup was to be used in the making of a new product called Coca-Cola. Fortunately, Ardrey was a good businessman with many successful ventures to his credit and could laugh about his brush with soft drink greatness. (Courtesy of the J.B. Mills Collection and Betty Mills Thomas.)

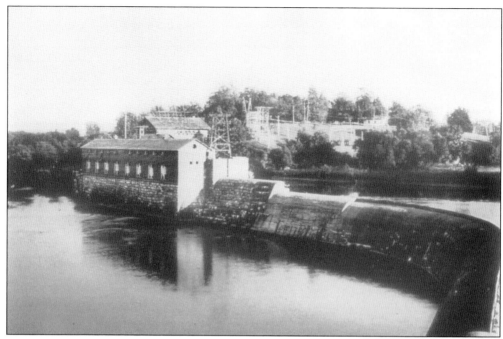

In 1905, the Catawba Power Company built this dam and hydroelectric plant on the Catawba River, pictured here in 1916. Construction of the dam resulted in the creation of Lake Wylie. The Catawba Power Company would eventually become industry giant Duke Energy. (Courtesy of the J.B. Mills Collection and Betty Mills Thomas.)

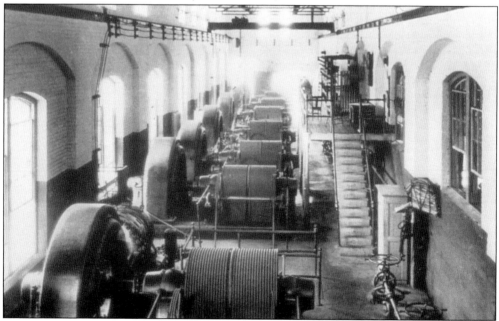

The interior of the hydroelectric powerhouse of the Catawba River Power Company is shown here in 1912. The alternators were driven by rope. Fort Mill was among the first towns to receive electric power contractually from Catawba Power Company. Previous town functions were powered by steam. (Courtesy of the J.B. Mills Collection and Betty Mills Thomas.)

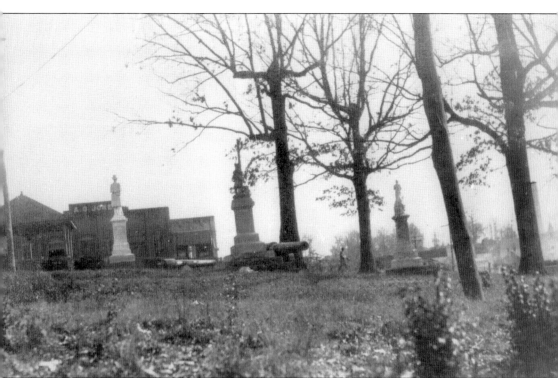

Confederate Park on Main Street was dedicated in 1891 and features the town's iconic bandstand (left) and four statues honoring groups who supported the war effort during the Civil War. This view faces Main Street. The Confederate soldier statue (left) lists the names of 170 veterans from Fort Mill. Other statues honor the women of the Confederacy (right) and the role of the Catawba Indians (center) in the struggle. The final monument (not visible), the only one of its kind for many years, was erected by local families to honor the "faithful slaves who, loyal to a sacred trust, toiled for the support of the Army." Passengers on the Southern Railroad congregated in the park to await trains that stopped at the adjacent depot, and guests of the hotels near Main Street relaxed here under the massive oaks. The cannons in the park are still fired every Fourth of July. (Courtesy of the Springs Close Family Archives.)

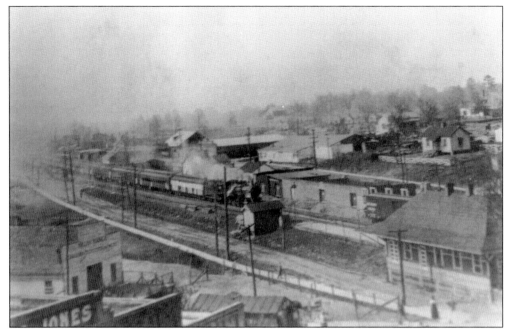

A northbound train of the Southern Railroad line prepares for arrival at the Fort Mill depot. Rail service to the town began in 1852 and continued until 1966. Early in the 20th century, more than a dozen passenger trains and freight lines stopped in Fort Mill each day. (Courtesy of the Springs Close Family Archives.)

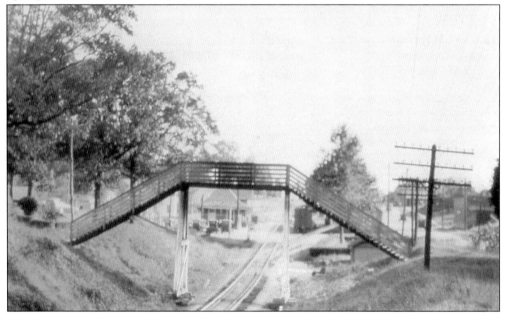

When trains were stopped at the depot, they blocked the base of Main Street, making it dangerous to attempt to cross on foot between the cars. For the safety and convenience of pedestrians, in the 1850s, the Southern Railroad built a wooden bridge that went over the parked trains and into Confederate Park. It was torn down in 1954. (Courtesy of the J.B. Mills Collection and Betty Mills Thomas.)

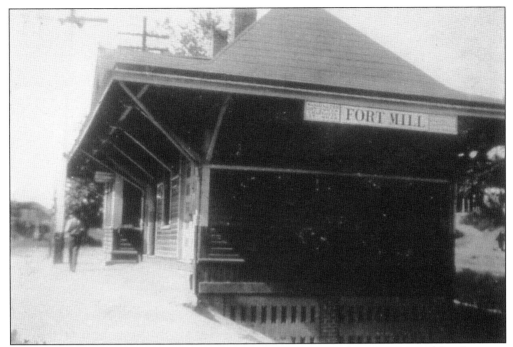

This depot, built by Southern Railroad, was the stopping point for passenger and freight trains arriving in Fort Mill. It was located on the east side of the railroad tracks, next to Academy Street. In 1987, the railroad tore down the depot without warning. (Courtesy of the J.B. Mills Collection and Betty Mills Thomas.)

A group of young people gathers at the water pump on Main Street around 1915. The pump was installed as a result of the fire of 1914, which caused significant damage to buildings on Main Street. It had been the third fire to wreak havoc on downtown businesses in less than 30 years. (Courtesy of the J.B. Mills Collection and Betty Mills Thomas.)

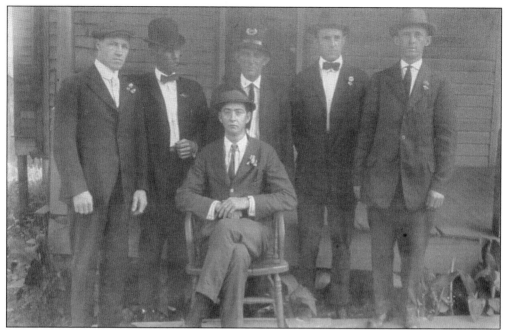

This photograph of the Fort Mill Town Council was taken in 1921 in front of the Palmetto Hotel on Confederate Street. Mayor Burke Patterson is seated before, from left to right, councilmen A.C. Lytle, Dr. J.B. Elliott, chief of police Walker Lynn, Jessie Harris, and Allie Ferguson. (Courtesy of the J.B. Mills Collection and Betty Mills Thomas.)

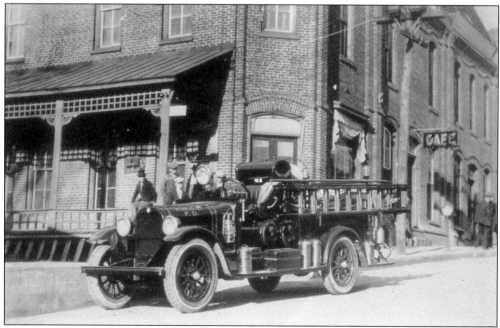

A bystander on the town hall porch checks out the town's first modern fire truck. It did not have a water pump, but rather two 30-gallon chemical tanks for fighting fires. The truck was a brand-new 1926 Dodge. It was a welcome addition after Main Street had suffered three devastating fires in previous years. (Courtesy of the J.B. Mills Collection and Betty Mills Thomas.)

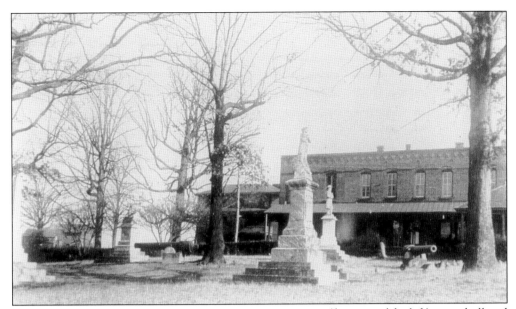

This view of Confederate Park includes the slave monument (foreground far left), town hall and the whittling porch (background right), and the Central Hotel (background left). This is the view Southern Railroad passengers would have had from the train's windows as they arrived at the Fort Mill depot. The photograph dates to 1922. (Courtesy of the J.B. Mills Collection and Betty Mills Thomas.)

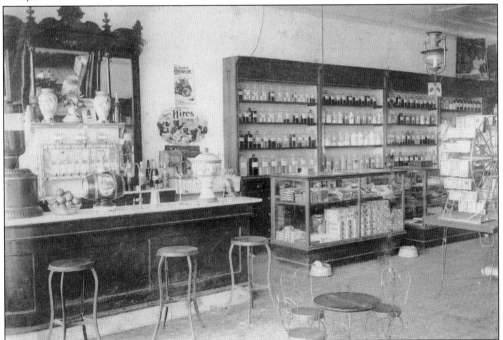

Ardrey's Drug Store was a popular destination on Main Street, and the soda fountain pictured here likely contributed to the store's appeal. In addition to the refreshments available at the counter, rows of dry goods in jars can be seen on the shelves to the right. (Courtesy of Fort Mill History Museum.)

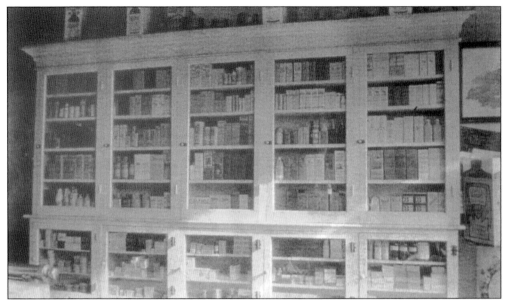

Ardrey's Drug Store was the place to find almost anything a Fort Mill resident could need. Be it items for the home, health, or farm, Ardrey and his fellow merchants kept shelves well stocked, making the town self sufficient. It was not necessary to go into Charlotte or Rock Hill for most needs, and Main Street flourished as the heart of the town. (Courtesy of the J.B. Mills Collection and Betty Mills Thomas.)

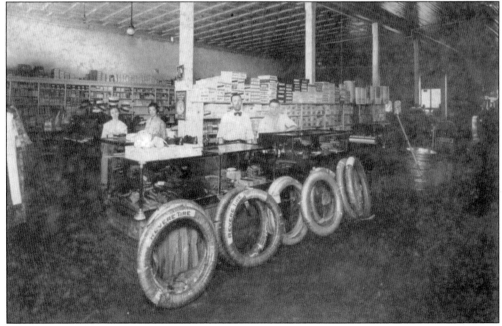

This Fort Mill store carried a variety of items, including bicycle parts and supplies. Cycling was a popular pastime in the early 20th century, and local merchant W.B. Ardrey was among the area's avid cyclists. The tires in this photograph would have fit the bicycles of the day, including the popular Monarch brand, one of which Ardrey ordered for himself at a cost of $35. (Courtesy of Fort Mill History Museum.)

In 1936, Fort Mill Manufacturing Plant No. 1 was one of six plants that made up the newly named Springs Cotton Mills. While its combat-pilot president Elliott White Springs returned to active duty at the start of World Word II, the plant began production of Type IV US Army uniform twill and provided more material to outfit American troops than any other company. (Courtesy of the Springs Close Family Archives.)

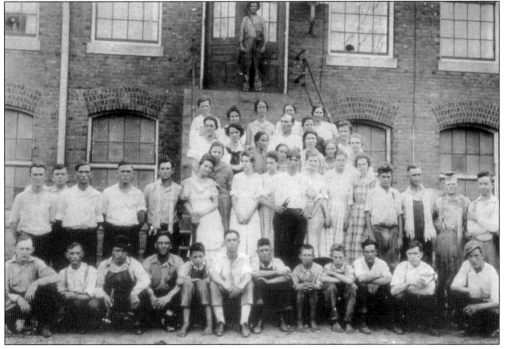

This large group of workers from the spinning room of Plant No. 1 poses for a photograph in 1916. At the time, the company was still called Fort Mill Manufacturing Company. Notice the children on the front row. It was not uncommon for children to work outside the home during this era. (Courtesy of the J.B. Mills Collection and Betty Mills Thomas.)

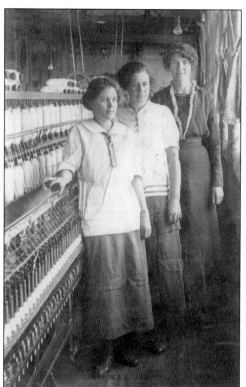

In 1914, three women work in the spinning room at Springs Cotton Mills in Lancaster, South Carolina. Annie Theodocia Lane (center) is the only woman identified in this image, which was donated by her daughter. (Courtesy of the Springs Close Family Archives.)

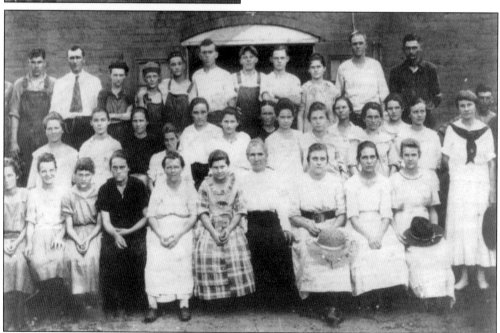

Employees at Springs Cotton Mills' White Plant pose for the camera outside the mill in 1923. The workers represent a variety of ages. The White Plant, located east of the railroad tracks near downtown, was also referred to as Fort Mill No. 2. (Courtesy of the Springs Close Family Archives.)

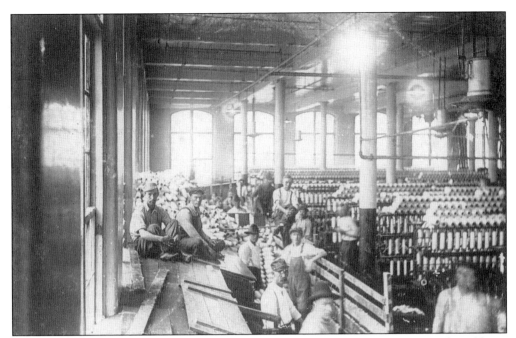

Spinning rooms were busy places at all the Springs mills. Cotton from the area was used in addition to supplies imported from other parts of the country to keep operations up and running. These men are taking a break from the job of keeping the machines loaded with full spools. Note the large pile ready to use in the background at left. (Courtesy of the Springs Close Family Archives.)

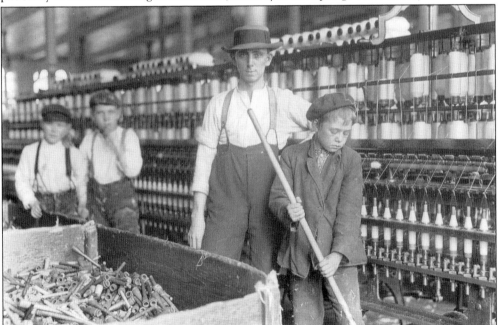

During the Depression, children were often a critical part of making ends meet for a family. Area youths found work in the mills alongside their parents or in place of parents who were unable to work. The careworn faces in this photograph from the 1930s are indicative of the stresses of the day. (Courtesy of Springs Close Family Archives.)

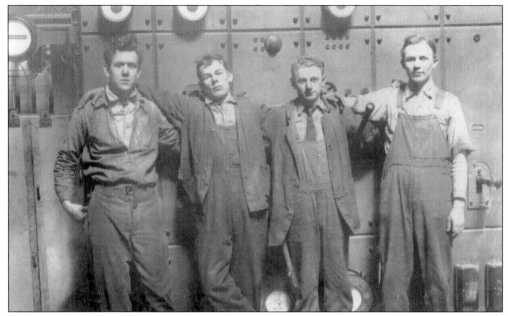

Millworkers pose for a photograph during the wiring of equipment in the Lancaster plant around 1928. The photograph belonged to Mary Merritt, who worked in the White Plant in Fort Mill for 30 years. Her father, J. Max Pope, is second from left. Pope met the woman who would become his wife in the plant, and the mill remained an important part of their family for generations. (Courtesy of the Springs Close Family Archives.)

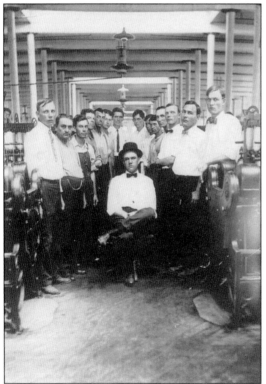

During the 1930s, Elliott White Springs was under considerable pressure to permit unionization of the mills, and agitators were continually encouraging employees to strike. Springs told them to go ahead and strike—he would close the mills and take his family to Europe. "I have enough money," he told them. Employees, like the men in this photograph, stood with Springs against the threat. (Courtesy of the Springs Close Family Archives.)

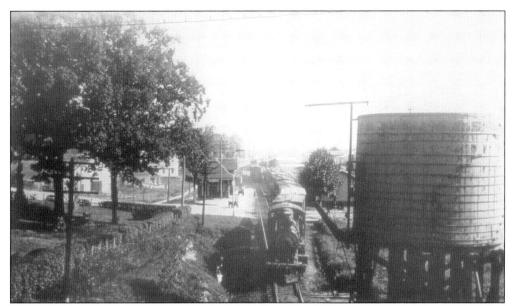

Visitors to the train tracks at the base of Main Street would have a much different view today. This shot, facing south, shows the Southern Railroad train as well as the water tower, which was used to fill the reservoir tanks for the steam engines. Confederate Park is to the left. (Courtesy of the J.B. Mills Collection and Betty Mills Thomas.)

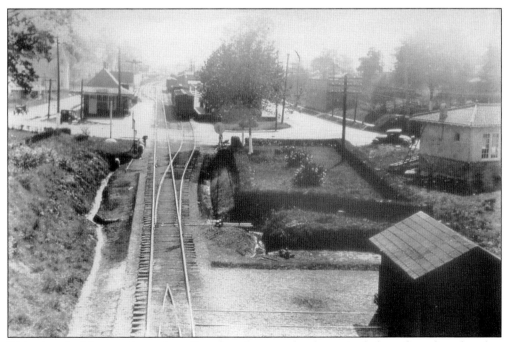

This view, looking south on the railroad tracks near the depot, includes a formal garden that was cultivated by E.L. Hughes, a maintenance section master for the railroad. A handcar used by employees to travel up and down the track for maintenance purposes was kept in the shed (lower right foreground) beside the tracks. (Courtesy of the J.B. Mills Collection and Betty Mills Thomas.)

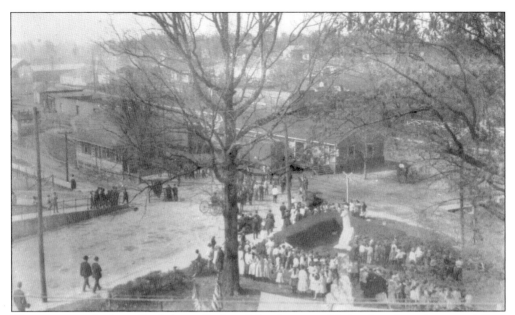

This image overlooking Confederate Park and the depot was likely taken from the second floor ballroom above town hall around 1895. It may have been the occasion of the dedication of the monument honoring the women of the Confederacy, as the crowd is gathered around that statue in the park. (Courtesy of the Springs Close Family Archives.)

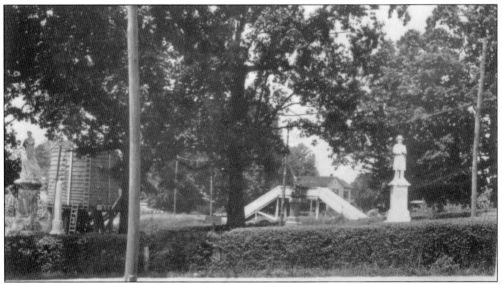

This view of Confederate Park shows where pedestrians would exit the wooden walking bridge that spanned parked trains. The water tower for refilling the tanks used to produce steam for the trains is visible at left, and the Confederate soldier monument stands at attention at right. (Courtesy of the Springs Close Family Archives.)

The *Fort Mill Times* newspaper was founded in 1892 by William Bradford Sr. It remained under the direction of a member of the Bradford family for 87 years. It occupied this building on the south side of Main Street until 2013. The paper is published weekly under the leadership of publisher Debbie Abels and editor Michael Harrison. (Courtesy of LeAnne Burnett Morse.)

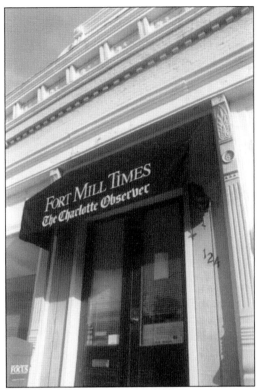

Men gather in front of A.O. Jones's grocery store around 1925. John Jones is the gentleman in the center of the photograph leaning on a box, which is actually a peanut vending machine. A horse and buggy can be seen alongside automobiles across the street. (Courtesy of Tommy Merritt.)

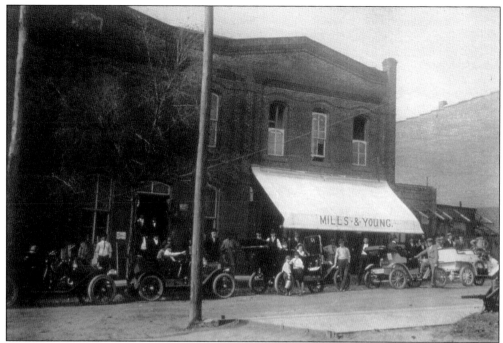

In the early 1900s, a group of men and boys poses with their fine automobiles in front of Mills and Young's general store on Main Street. The store, owned by Barron Mills and James Young Sr., carried a wide variety of items from dry goods to farm supplies and hardware. (Courtesy of the Springs Close Family Archives.)

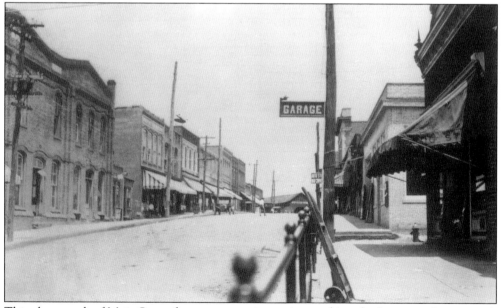

This photograph of Main Street features a prominent sign marking the location of a garage. A protruding object in the shape of a hand with a finger pointing down Confederate Street is in the upper left corner of the sign. Although unverified, it may have been a reference to the fire department garage in that vicinity as early as 1940. (Courtesy of the Springs Close Family Archives.)

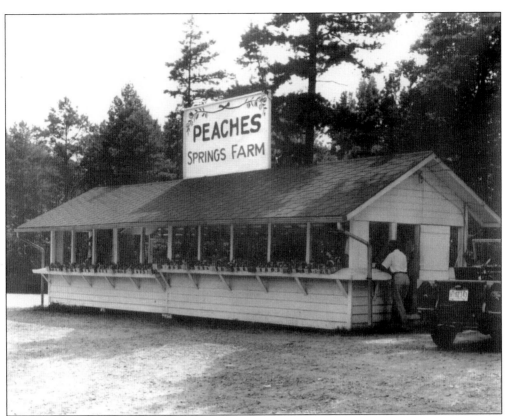

The peach stand (above) is one of the best-known landmarks in Fort Mill. This original stand, built in 1924, was *the* place to buy fresh fruit and vegetables, particularly peaches and strawberries, from the thousands of acres of Springs Farm. Produce was delivered right from the fields to the stand throughout the day. The stand is still operated during the summer months, with the addition of a modern Peach Stand store across the street that is open year round. The store boasts a restaurant, butcher shop, ice cream shop, gourmet food and gift shop, gasoline, sundries, and, of course, fresh peaches. (Both, courtesy of the Springs Close Family Archives.)

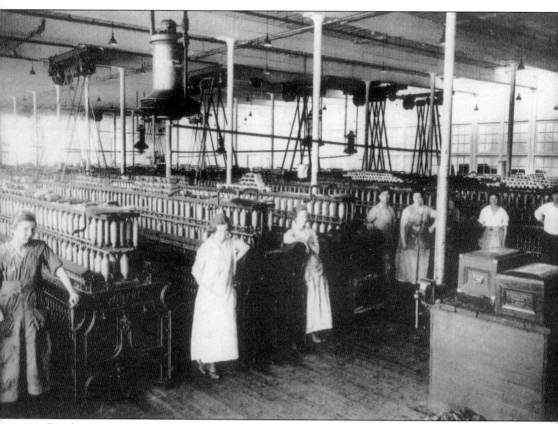

Employees pose in the spinning room of Fort Mill Plant No. 1 in 1919. Included in the photograph are Beulah Baker, Pauline Elms, Daisy Bass, and McCampbell Stamper. With the men on the front lines, local women took on the important work of keeping the mill running and the town prospering. Both Fort Mill plants kept up with production during the war, the volatile 1920s, and the dark days of the Depression, when the market for goods all but dried up. When World War II began and Springs Industries had a large stockpile of goods ready for market, the decision to produce during the lean times proved to be a good business decision. It had also kept workers employed and families fed. Whether there was a war in progress or not, women would be a large and important part of the workforce as long as the mills operated. (Courtesy of the Springs Close Family Archives.)

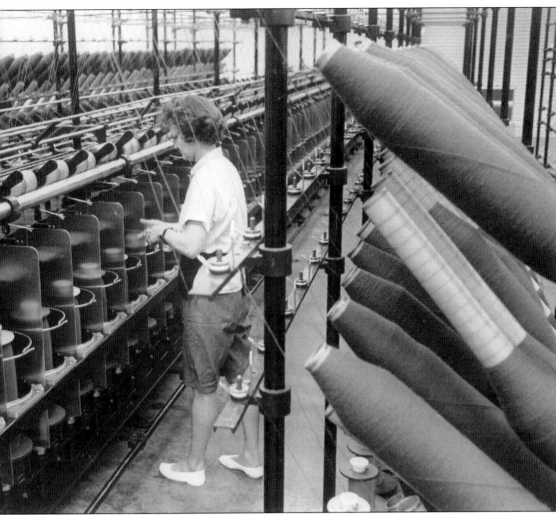

With changes in technology, the basic process of spinning and weaving underwent upgrades and increased automation. Still, this shot inside one of the spinning rooms shows a remarkably similar, slightly more streamlined machine. Notice there is only one worker in this photograph from the 1960s, instead of a handful in earlier days. As the company expanded, Elliott White Springs added new functions to the burgeoning empire. Once content with producing unfinished cloth, he decided the company could move into a greater market with finished goods and added the Grace Bleachery near the Catawba River. The addition of this facility made it possible to develop the Springmaid line of products that would be found in homes across America. Innovation was part of the DNA of Springs Industries from humble beginnings in a single Fort Mill plant to an industry giant. (Courtesy of the Springs Close Family Archives.)

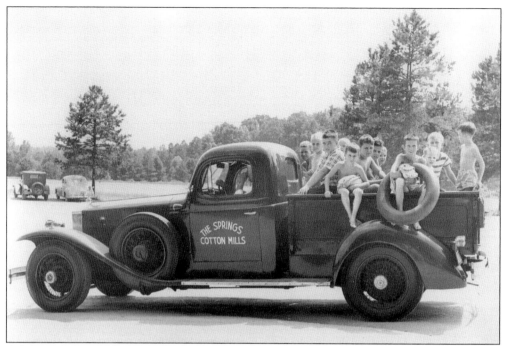

A Springs Cotton Mills truck filled with children makes its way to a lake outing in the 1940s. The company planned regular events for the families of millworkers. These events were sometimes held at company-owned Springmaid Park in nearby Lancaster or at Springmaid Beach, the company's beach resort on Myrtle Beach. (Courtesy of the Springs Close Family Archives.)

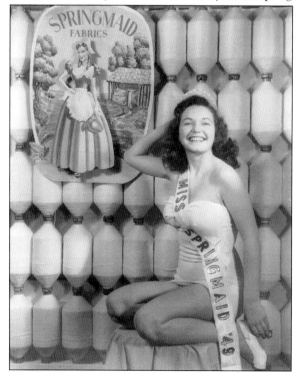

Miss Springmaid 1949, Ann Sellers, poses with the company logo and spools of thread. From 1948 until 1951, each mill held a yearly pageant to choose its representative, and those winners went on to the larger, company-wide pageant. The winner was sent on a dream trip to New York City and was chauffeured about town in Colonel Springs's personal Rolls-Royce limousine. (Courtesy of the Springs Close Family Archives.)

Elliott White Springs pioneered the use of double entendre in marketing with a series of risqué advertisements for Springmaid products. "A Buck Well Spent on a Springmaid Sheet" is the most famous of the series. It first appeared in *Collier's* magazine in April 1950 and was featured in Springmaid calendars for several years. (Courtesy of the Springs Close Family Archives.)

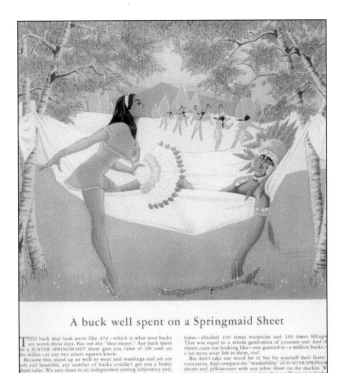

A buck well spent on a Springmaid Sheet

"Protect Your Assets" was another successful advertisement in the Springmaid campaign. The 1950 advertisement recommended wearing garments made of Springmaid fabrics to protect what was underneath. Consumers of the day were not accustomed to seeing undergarments in advertisements, and the appearance was viewed as somewhat scandalous. (Courtesy of the Springs Close Family Archives.)

51

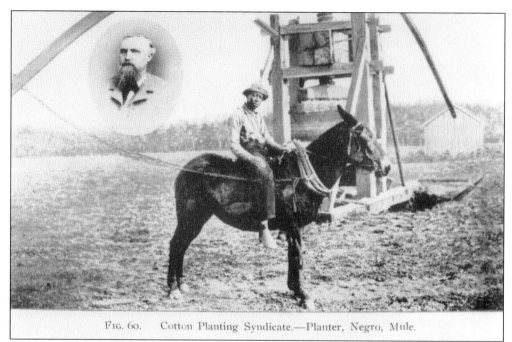

FIG. 60. Cotton Planting Syndicate.—Planter, Negro, Mule.

Planter Samuel E. White is shown in this composite photograph along with a laborer who is operating a mule-driven cotton gin on White's plantation around 1873. This early type of ginning was prevalent before the Civil War and was considered crude compared to later improvements. The process yielded cotton lint for making low-quality cloth, nothing like the high-quality materials the Springs companies would later produce. (Courtesy of the Springs Close Family Archives.)

This image of Clebourne Street dates to 1904. The Jones home is second from the corner, and the Clebourne Street corridor led to the area of town known as Maybee Hollow. (Courtesy of Fort Mill History Museum.)

Three

THE SPRINGS FAMILY
BUILDING A LEGACY

Fort Mill is made up of families whose names we know and those we have not heard. Each contributes to the fabric of the town in unique ways, every one valuable and worthy. One family has been part of the growth and culture of Fort Mill in ways that have impacted virtually every citizen of the town in ways large and small. The Springs family has built a legacy of service here from the early days after the Civil War through the development of the mills and on to philanthropic and preservation efforts in the 21st century. From Samuel E. White's development of Confederate Park to Elliott White Springs's mill operations during the Depression to Anne Springs Close's magnificent greenway, the Springs family has been giving back to the citizens of Fort Mill for generations.

Leroy Springs was the son-in-law of Samuel E. White. He is pictured here in the uniform of a colonel on Gov. John Peter Richardson's staff in attendance at the 1886 dedication and parade for the Statue of Liberty in New York. Legend says he was chosen for his expertise with horseflesh, as Richardson was convinced the Yankees would give him a difficult horse for the parade. (Courtesy of the Springs Close Family Archives.)

Dr. William Edward White was a brother to Samuel E. White. He was one of five brothers to join the Confederate army, though his service was cut short with his death from camp fever in November 1861. White was a graduate of Davidson College and the medical school at the University of New York; he served his regiment as an assistant surgeon. (Courtesy of the Springs Close Family Archives.)

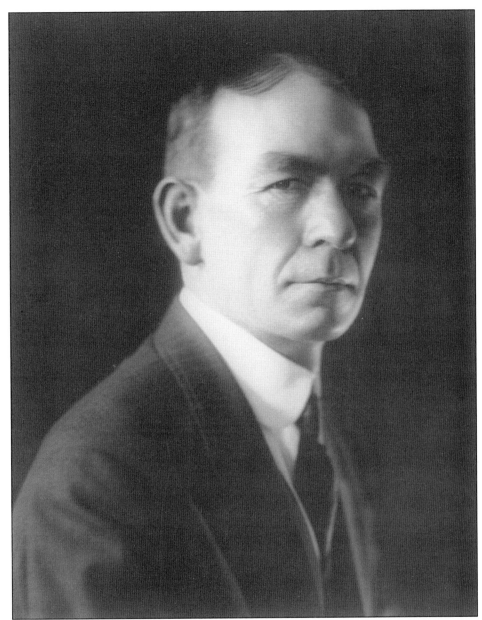

Leroy Springs was born at Springfield Plantation in 1861 and later became the son-in-law of Samuel Elliott White when he married White's daughter, Grace Allison. In 1896, he started Leroy Springs and Company in Lancaster and later took over management of Fort Mill Manufacturing Company upon the death of his father-in-law. Springs continued to acquire mills, ultimately overseeing five in South Carolina. They were operated as separate companies and would be consolidated under the management of his son, Elliott White Springs, in 1933. In 1928, a cotton buyer unhappy with Springs's business decisions shot him in the head. Springs recovered but had lost interest in running the company and turned the day-to-day operations over to his son. He died on April 9, 1931, and was buried on the front lawn of the Lancaster Cotton Mill per his wishes. The company he left his son was valued at more than $7.2 million and employed 5,000 people. (Courtesy of the Springs Close Family Archives.)

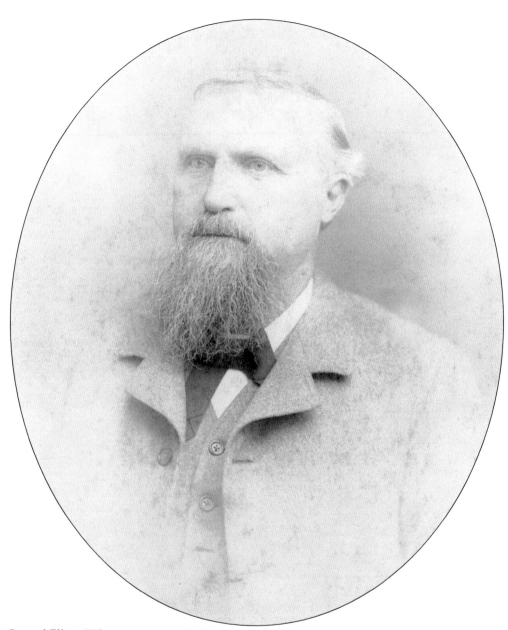

Samuel Elliott White was patriarch of a large family that would positively impact Fort Mill for generations. He was born at the White Homestead in 1837 and attended the Citadel in Charleston before signing up to fight for the Confederacy. Upon his return to Fort Mill, he turned his attention to several successful business ventures, including cotton production and banking, but it was his creation of Fort Mill Manufacturing Company in 1887 that would change the fortunes of an entire town. His son-in-law, Leroy Springs, and his grandson, Elliott White Springs, would take what he started and turn the company into a worldwide brand leader. The precursor to Springs Industries and the Springmaid brand, the new mill brought employment to thousands and a ready buyer to cotton farmers in the region. Captain White, as he was known after his Civil War service, was responsible for planning and financing the development of Confederate Park and the monuments there. White died in 1911 and is buried at Unity Cemetery.

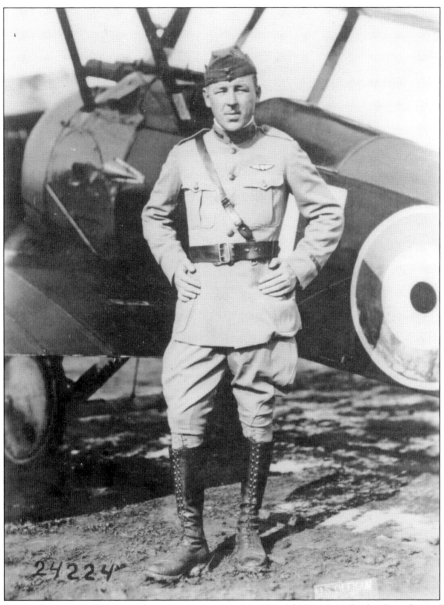

A native of Fort Mill, Elliott White Springs served in World War I with the Royal Air Force, garnering an impressive combat record before reassignment to the 148th Aero Squadron of the US Air Service. He is pictured here in 1918 at the rank of captain and would later achieve the rank of colonel. Springs ultimately rose to command his unit and built a reputation culminating with recognition as the service's fifth-ranked flying ace. After the war, he returned to Fort Mill and took over management of the Fort Mill Manufacturing Company at the request of his father. With a knack for fearless, somewhat risqué marketing and a single-minded devotion to his workers, he grew the company into the textile giant brand Springmaid. Through the lean years of the Great Depression, he kept the mills operating so workers could earn a living, even though he had no buyers for his goods. The Springs family name is still prevalent in business, conservation, and philanthropic endeavors in the area because of his legacy. He was known far and wide simply as "the Colonel." (Courtesy of the Springs Close Family Archives.)

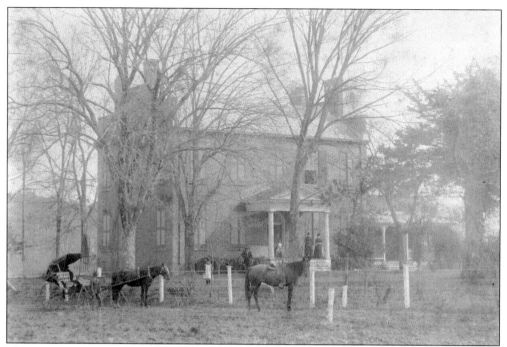

Visitors arrive by horse and buggy at the White Homestead around 1870. Originally built for William Elliott White in 1831, this Federal-style home hosted the last meeting of the Confederate Cabinet on their flight from Richmond, Virginia, in 1865. It later became home to Elliott White Springs, president of Springs Industries, and today houses the Springs Close Family Archives. (Courtesy of the Springs Close Family Archives.)

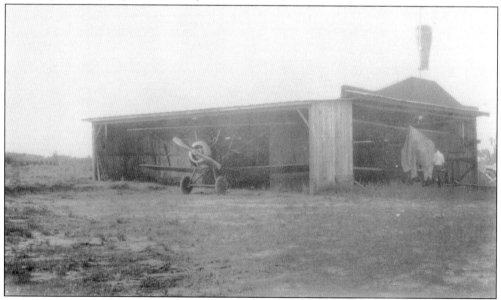

Elliott White Springs brought his love of flying home to Fort Mill and maintained a hangar and landing strip on land next to the White Homestead. Today, this bucolic pasture is home to grazing horses that are part of the Anne Springs Close Greenway equestrian program. Horseback riding lessons and trail rides are held at the nearby stables. (Courtesy of the Springs Close Family Archives.)

Elliott White Springs is pictured here in 1922 in his wedding attire. He married Frances Hubbard Ley on October 4 of that year. At this time in his life, he was already well known as a flying ace in World War I and the heir apparent to the helm of Fort Mill Manufacturing Company. (Courtesy of the Springs Close Family Archives.)

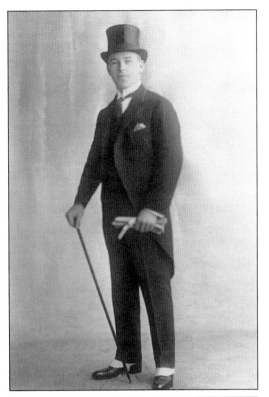

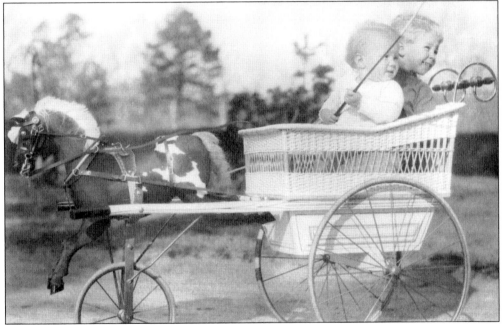

The children of Col. Elliott White Springs and his wife, Frances Hubbard Ley Springs, are pictured here on the lawn of the White Homestead around 1926. Leroy "Sonny" Springs II was born in 1924, and his sister, Anne Kingsley Springs, followed in 1925. She was known as "Sis." (Courtesy of the Springs Close Family Archives.)

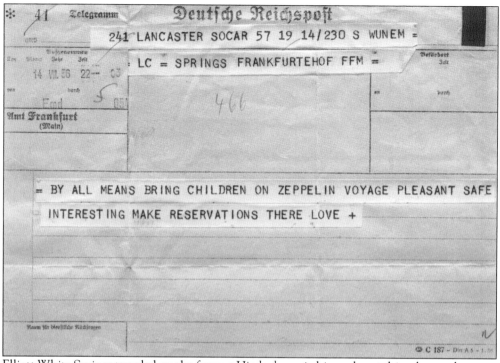

= BY ALL MEANS BRING CHILDREN ON ZEPPELIN VOYAGE PLEASANT SAFE

INTERESTING MAKE RESERVATIONS THERE LOVE +

Elliott White Springs traveled on the famous *Hindenburg* airship and sent this telegram home to his wife in Fort Mill, encouraging her to make arrangements for a trip to include the children. He described the voyage on the zeppelin as "pleasant, safe, and interesting." As part of the resulting journey, Frances Springs attended the 1936 Olympic Games in Berlin, Germany. (Courtesy of the Springs Close Family Archives.)

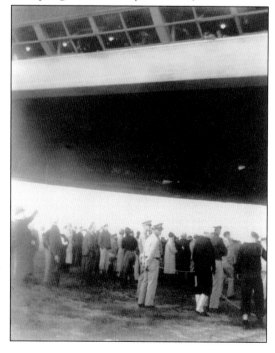

Sonny and Anne Springs are seen peering over the edge of the viewing deck window of the *Hindenburg* on September 17, 1936. Elliott White Springs was so fond of the design of the deck and gallery windows that he incorporated a similar design into the corporate headquarters building for Springs Industries. (Courtesy of the Springs Close Family Archives.)

Frances Ley Springs is pictured here with her children, Sonny and Anne, on September 17, 1936. She was honored as the 1,000th passenger on the German airship *Hindenburg*. As a token of remembrance, she was given an engraved platter made of the same lightweight silver aluminum that made up the outer skin of the zeppelin. (Courtesy of the Springs Close Family Archives.)

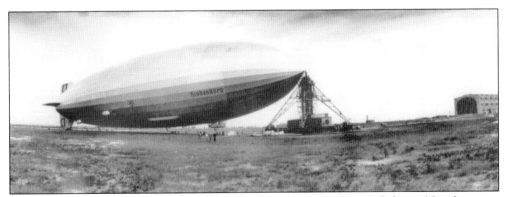

The *Hindenburg* is pictured here on the ground at its landing spot in Lakehurst, New Jersey, in September 1936. Eight months after the Springs family made a successful crossing on the craft, it famously met a tragic end in a fireball above Lakehurst Naval Air Station. Its destruction marked the end of airship travel worldwide. (Courtesy of the Springs Close Family Archives.)

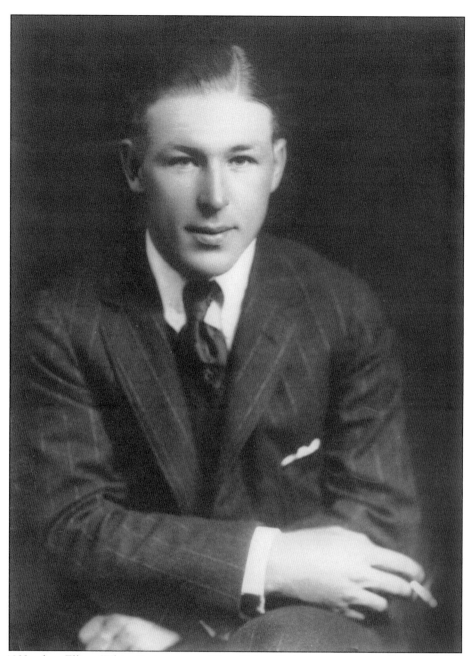

In 1933, when Elliott White Springs consolidated his mills into one company he named Springs Cotton Mills, he was setting the stage to take it from corporation to empire, and he would do it with an unlikely item—sheets. Once sold as dry good items, all sheets were flat, white, and utilitarian. They were offered on store shelves in much the same way staple items like soap or farm implements were carried. Springmaid changed that with the introduction of floral and stripe patterns, see-through packaging, and a unique advertising campaign that hinted at sex and made the sheets a must-have item for housewives everywhere. Bed linens were suddenly fashionable, and the flying ace who had wanted to spend his life writing books was suddenly the head of the world's most well known domestics brand. (Courtesy of the Springs Close Family Archives.)

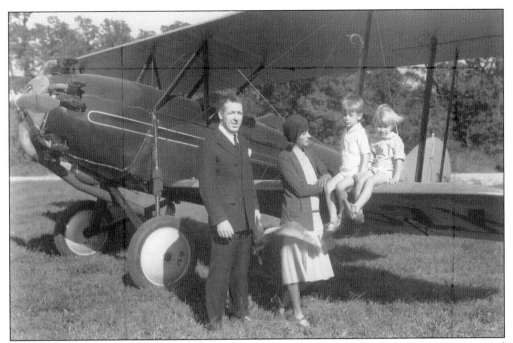

Elliott White Springs had been a fighter pilot and flying ace in World War I and was a noted private pilot later in his life. He was often seen above the skies of Fort Mill in his propeller-driven aircraft. He is pictured here with his wife, Frances, and children, Sonny and Anne. Frances Springs was a fellow pilot herself. (Courtesy of the Springs Close Family Archives.)

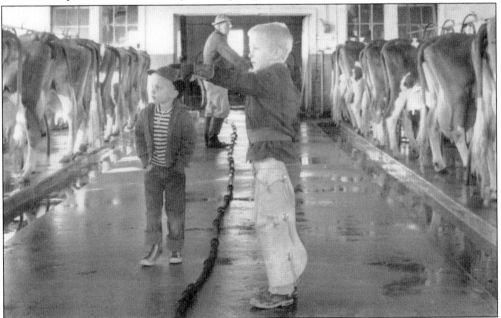

Two of Elliott White Springs's grandsons visit the milking room of the dairy barn about 1957. Elliott "Ell" Springs Close (left) and Leroy "Buck" Springs Close (right) are shown here during the heyday of the dairy's operation. They are the sons of Bill and Anne Springs Close. (Courtesy of the Springs Close Family Archives.)

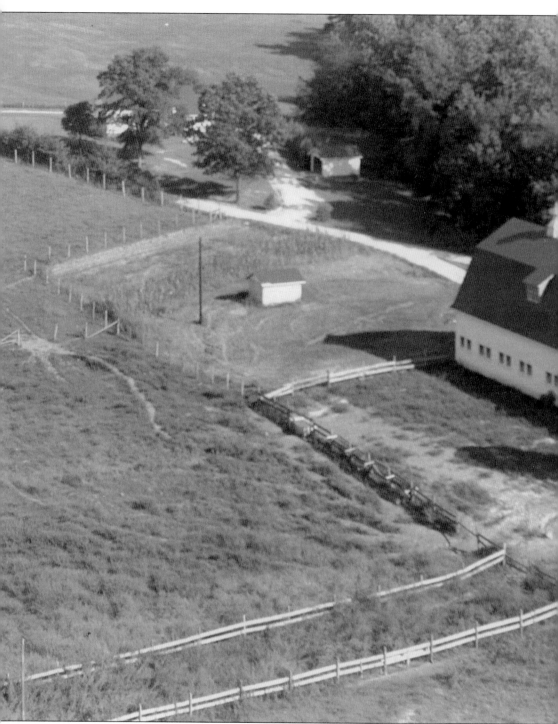

This aerial shot of the Springs Farm dairy barn was taken in 1953. The barn is located on land adjacent to Springfield Plantation. Locals considered it Colonel Springs's folly because he built the barn for cows he bought on a whim to see what it would be like to own cows. The dairy became yet another successful enterprise for Springs Industries. The dairy itself is no longer in

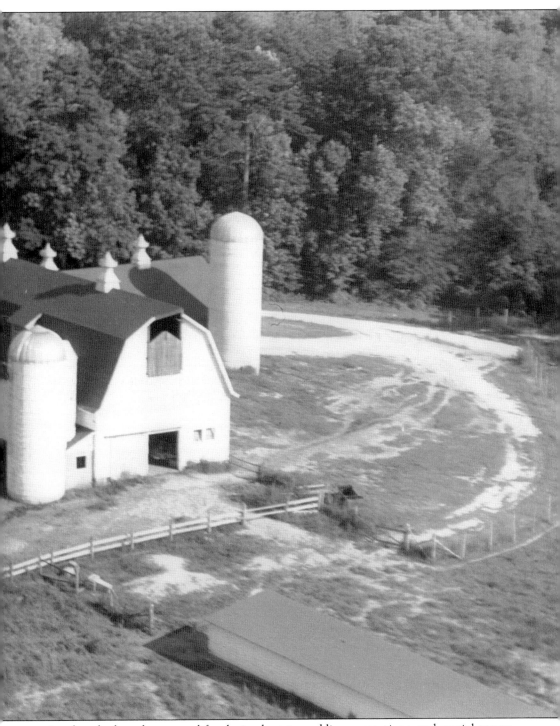

operation, but the barn has a new life, playing host to weddings, receptions, and special events in its cavernous, rustic interior and on its extensive park-like grounds. (Courtesy of the Springs Close Family Archives.)

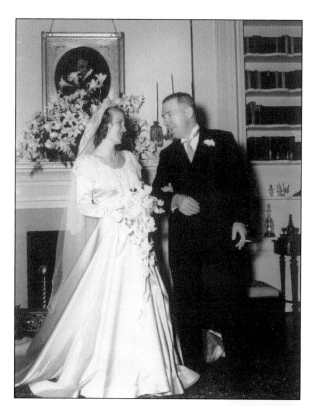

Col. Elliott White Springs is pictured here with his daughter, Anne, on the occasion of her wedding to Hugh William "Bill" Close in November 1946. The photograph was taken in the parlor of the White Homestead, and the wedding was held at Unity Presbyterian Church. (Courtesy of the Springs Close Family Archives.)

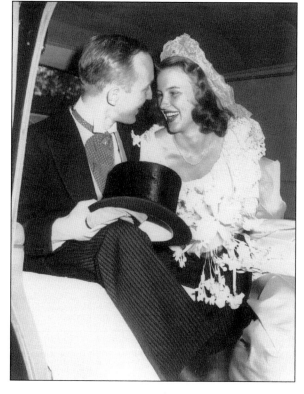

Anne Springs is shown here with her new husband, Bill Close, on their wedding day in 1946. Close was a graduate of the Wharton School of Business and a World War II Navy veteran. He learned the Springs Industries business from the ground up and led the company as president for 24 years after the death of Colonel Springs. He died in 1983. (Courtesy of the Springs Close Family Archives.)

Princess Grace is shown here in 1978 working on the design for the Grace Kelly Collection of exclusive linens for Springmaid. The American-born Princess of Monaco created the pressed-flower collage image, which was a top seller for the company. She donated her proceeds to various charitable causes of which she was patroness. (Courtesy of the Springs Close Family Archives.)

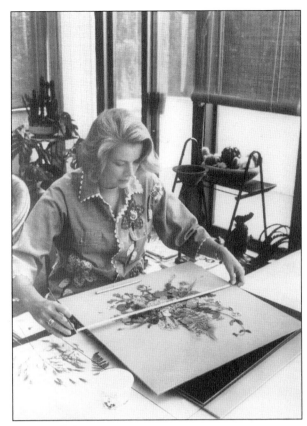

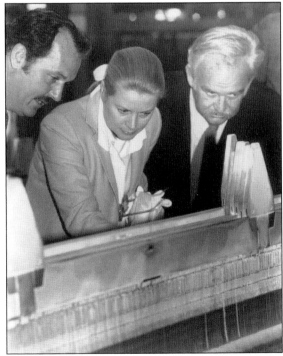

Princess Grace and Prince Rainier of Monaco inspect a section of the production process with plant manager Butler Nanney at the Katherine Plant on July 23, 1979. The royals visited several Springs facilities and attended a luncheon with Bill and Anne Close at the White Homestead during their visit. (Courtesy of the Springs Close Family Archives.)

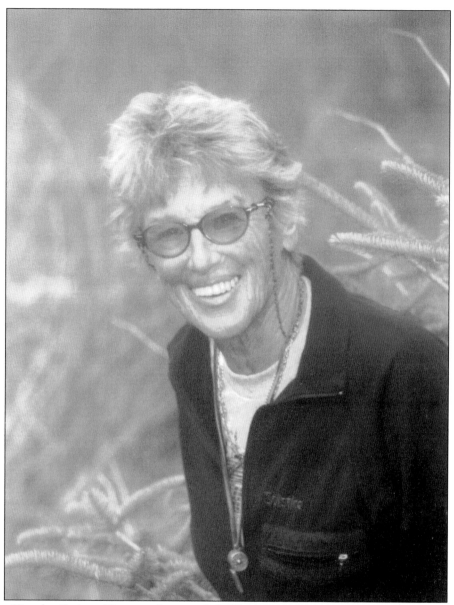

Anne Kingsley Springs Close was born to Col. Elliott White Springs and his wife, Frances, in 1924. She married Hugh William Close in 1946, and together they raised eight children. She is now grandmother to 24. Through the years, she has been a dedicated patron to the town of Fort Mill, with an emphasis on recreation, environmentalism, and land preservation. A longtime outdoor enthusiast, Close remains active in charity runs and in the direction of equestrian camp programs for handicapped children and adults in addition to her business role as board chair for the Springs Close Foundation and Leroy Springs & Company, Inc. Perhaps her greatest legacy will be the Anne Springs Close Greenway, a 2,200-acre permanent land conservancy that was dedicated in 1995. The Trust for Public Land and the Foundation for the Carolinas recognized Anne Springs Close in 2001 for her work with the ASC Greenway and the Palmetto Trail, which joins the greenway and forms a 320-mile walking trail that stretches from the mountains to the sea. (Courtesy of the Springs Close Family Archives.)

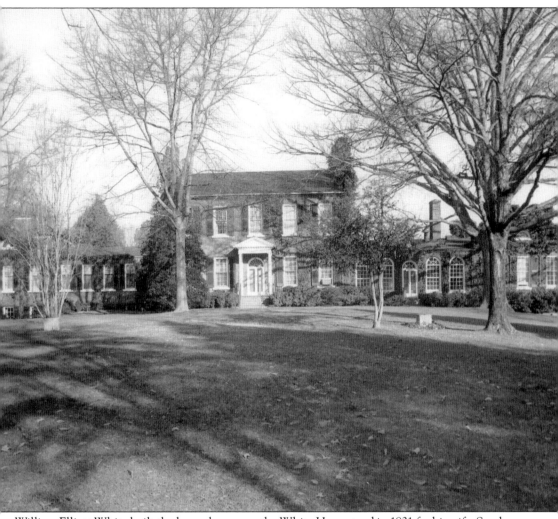

William Elliott White built the house known as the White Homestead in 1831 for his wife, Sarah, and their growing family. The cost of construction for the Federal-style manor was $5,000. The four-story structure included a separate brick kitchen, as was the custom of the day, to prevent potential fires from spreading to the main house. Federal troops burned the kitchen at the end of the Civil War in 1865. White's son David inherited the house upon his father's death, and later sold it, along with 1,160 acres of land, to his brother Samuel E. White for $500. The house was unoccupied from 1877 until 1922 when White's grandson, Elliott White Springs, began an extensive remodeling and enlargement project. Springs and his wife, Frances, raised their children, Anne and Leroy, in the home. It is most famously recognized as the site of the last Confederate Cabinet meeting. The home was restored to its original condition in 1991 and now serves as the headquarters for the Springs Close Family Archives. It is listed in the National Register of Historic Places. (Courtesy of the Springs Close Family Archives.)

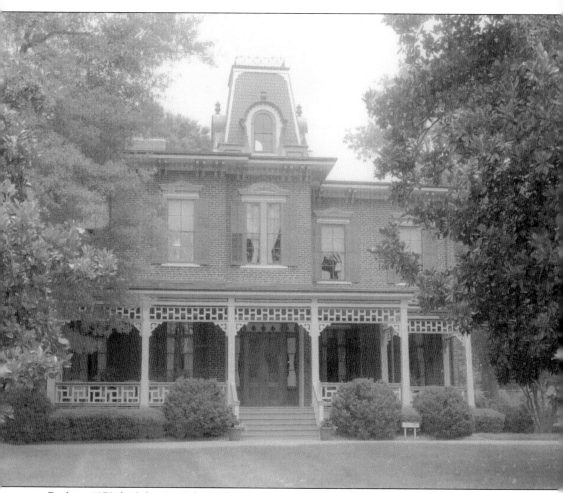

Built in 1872 for John M. White, this stunning Italianate house takes pride of place for visitors arriving in Fort Mill's historic downtown area. Wrought-iron fencing and beautifully landscaped grounds surround the property, and warm light glows from the windows when night descends. The house was built during the period of Reconstruction after the Civil War and also displays features of the Second Empire style in addition to its predominant Italianate architecture. A brick cottage located on the grounds was the home of Lillie Phifer, the daughter of a former slave whose family had emigrated to Liberia after the war and later returned to the area and worked for the Springs family. Today, the house is known as the Springs Guest House and has been listed in the National Register since 1985. (Courtesy of the Springs Close Family Archives.)

Four

SMALL-TOWN SACRIFICE
ANSWERING THE CALL TO SERVICE

Fort Mill is just a tiny dot on a map of the world, but its citizens have answered the call to service in the far reaches of the globe. They have served in the trenches of Camden and Gettysburg, lit the skies on fire over Germany, and died on the battlefields of France. The town's sons and daughters have never neglected the call to arms nor been lax in supporting those who return home to live in peace. Since the Catawba first called this land home in the 17th century, those who share this sense of place have been leaving it whenever duty called for the protection of the greater good.

At the time of the outbreak of the Civil War in 1861, young men were rushing to join the Confederate cause, believing the war would be short and any delay might result in their missing out on the romance and adventure they imagined. Some went so far as to lie about their ages in order to join the ranks before they were truly old enough. The identities of the boys in these photographs are not known, but their youth is evident. Even if these young men were of age at the time of enlistment, they could not have imagined the long nightmare ahead. Fort Mill sent many to fight, and these young men were among those who took up arms. (Both, courtesy of the Springs Close Family Archives.)

Joseph W. Parks poses in front of the Confederate soldier monument in Confederate Park. A veteran of the war, he was with Gen. Robert E. Lee when he surrendered to Gen. Ulysses S. Grant at Appomattox Court House in 1865. The father of 24 was known around town as the man who had lived to see two appearances of Halley's Comet. (Courtesy of the J.B. Mills Collection and Betty Mills Thomas.)

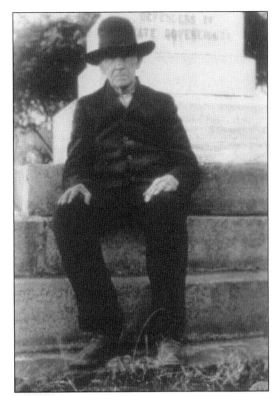

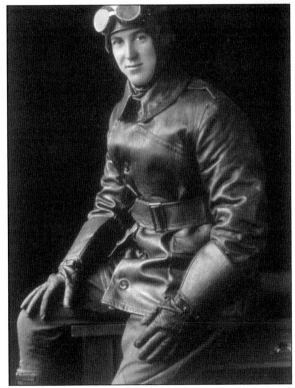

Theodore Harris, pictured here in 1917, was a test pilot during World War I. Fort Mill saw a high percentage of young men off to the war in Europe given the size of the town. They acquitted themselves honorably, and a memorial park to the soldiers of this and other 20th-century wars was dedicated in 2011. (Courtesy of the J.B. Mills Collection and Betty Mills Thomas.)

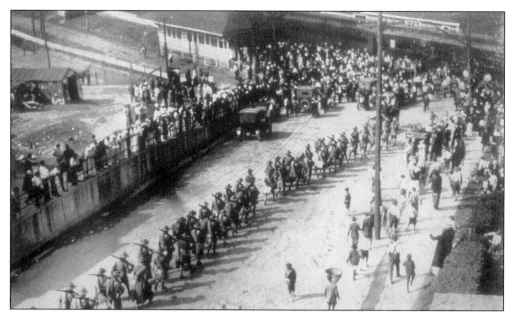

National Guard troops from Fort Mill muster at the rail station before crowds of onlookers. The unit would form Company G of the 118th Infantry and would serve with distinction and acclaim as the first to break through the infamous Hindenburg Line. They trained together in Chickamauga, Georgia, and were the first regiment in the 30th Division to arrive in France. Native Thomas Lee Hall received the Medal of Honor for meritorious service at Montbrehain, France. He was mortally wounded there on October 8, 1918. Booth Street was renamed Tom Hall Street in his honor. (Above, courtesy of the J.B. Mills Collection and Betty Mills Thomas; below, courtesy of Tommy Merritt.)

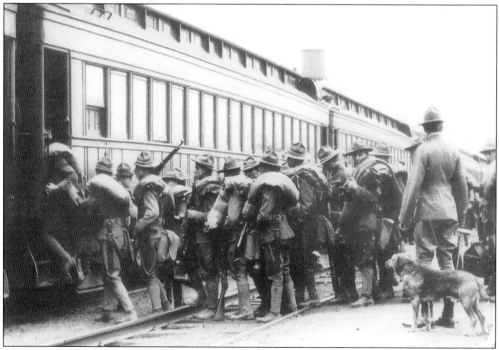

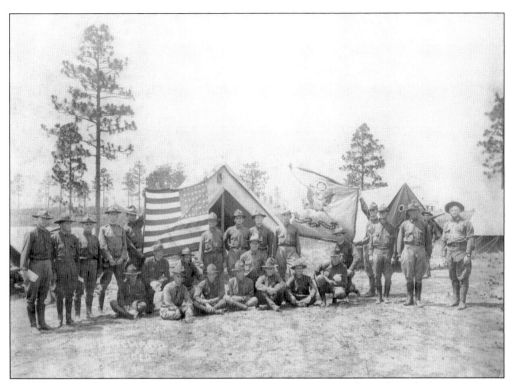

In 1918, when Company G arrived in Belgium, they were attached to a British Army regiment and moved into France. From July 4 until October 20, the men endured daily enemy shelling with only a 10-day respite from the onslaught. The German Hindenburg Line had been dug in for two years and was considered impregnable. On September 29, after a 56-hour offensive bombardment, troops of the 118th broke through the lines in what came to be known as the Battle of St. Quentin Canal. The regiment continued to drive the Germans back 18 miles, across the La Selle River. (Both, courtesy of Fort Mill History Museum.)

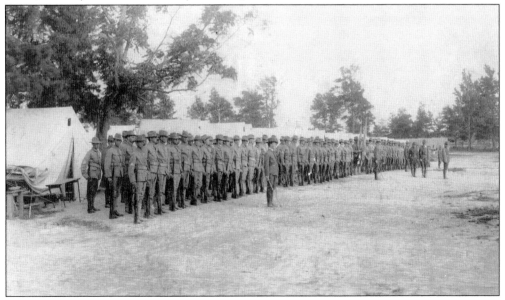

In 1919, Main Street and the bandstand at Confederate Park are dressed in patriotic finery to welcome home troops of the 118th Infantry's Company G. The local soldiers were heralded as heroes both far and wide for their role in breaking the infamous Hindenburg Line. After months of constant bombardment by enemy shells, horrendous trench conditions, and the daunting task of breaking through a line so firmly entrenched it was considered unbreakable, the brave soldiers of the 118th pushed their way through the defenses and continued forcing the Germans into retreat for miles beyond the line. Crowds had gathered at the train depot in Fort Mill to see them off for training at Chickamauga, Georgia, before their deployment to Europe and stood ready to welcome them home with all the pomp and fanfare befitting their gallant service. (Courtesy of the Springs Close Family Archives.)

Five

MIND, HEART, AND SOUL
SCHOOLS, CHURCHES, AND THE ARTS

Faith and family are hallmarks of small-town life. This is true in Fort Mill, where settlers began establishing houses of worship in the early days of the town's development. Throughout the years, a focus on education has also become a much-lauded quality of Fort Mill. The award-winning school district can trace its commitment to excellence back to the establishment of the first private academies and public schools in the area. In addition to these traditional institutions, town residents have always shown an interest in supporting the arts, perhaps none more than music. Bands could be heard on Main Street throughout the town's history, including the 1920s, when the Fort Mill Band played at the bandstand in Confederate Park. Today, high school marching bands with scores of prestigious titles to their credit parade down Main Street at the annual Christmas parade and on the streets of Tega Cay for the Fourth of July. Artists working on canvas, in clay, and in various other mediums display their talents at a yearly festival, and dramatic arts and dance companies command priority in schools and in civic venues. Mind, heart, and soul can all find edification in Fort Mill.

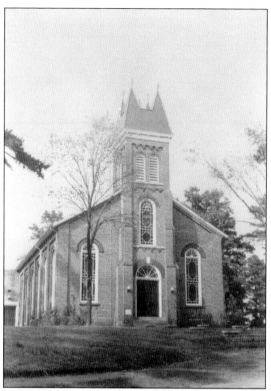

Fort Mill's oldest church, Unity Presbyterian, was founded in 1788. The congregation was formed by English and Scottish settlers whose loyalties ran to both the House of York and the House of Lancaster. Though traditionally at odds, an effort was made to leave old grudges in the past, and the name Unity was chosen to represent the new start in this new world. (Courtesy of Unity Presbyterian Church.)

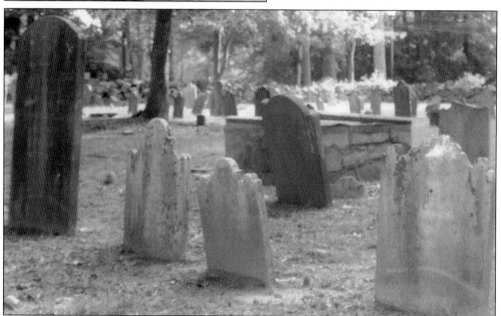

Old Unity Cemetery is among the oldest in Fort Mill, with gravestones dating to the late 1700s. The cemetery is beautifully maintained and surrounded by a stacked-stone wall. It is located at the corner of Marshall and Unity Streets, near the site of the original Unity Presbyterian Church. Many members of the town's founding families were laid to rest at this site. (Courtesy of LeAnne Burnett Morse.)

At the age of 97, J. Ben Patterson gave a description of the original structure used by the First Methodist Church to a local artist. The building, located on Cleborne Street, dated to 1875 and had been torn down in 1892. Patterson's description resulted in this drawing. He was the only person still living who had actually seen the building. (Courtesy of the J.B. Mills Collection and Betty Mills Thomas.)

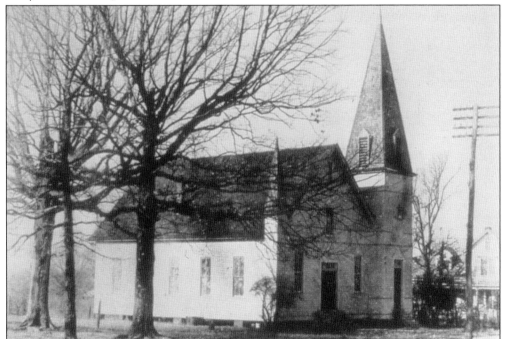

In 1875, a Methodist church was established in Fort Mill. It was founded by 74 members and located in a wooden structure on Clebourne Street. They named it St. John's. The building pictured here in 1890 was the second used by the church, when it was known as St. John's Methodist Episcopal. (Courtesy of the J.B. Mills Collection and Betty Mills Thomas.)

This is St. John's today. Now known as St. John's United Methodist Church, the redbrick sanctuary stands on Tom Hall Street, a few blocks from Main Street. This building has been in use since 1946 and now includes a fellowship hall addition from the late 20th century. (Courtesy of St. John's United Methodist Church.)

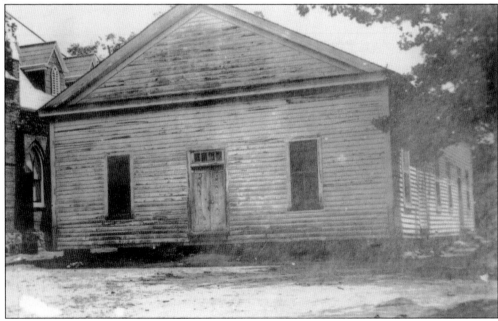

Flint Hill Baptist Church is among the oldest congregations in Fort Mill. It was established originally as Sugar Creek Baptist Church of Christ in 1792 by Rev. John Rooker, his wife, Anna, and 11 friends. The structure in this photograph dates to 1855. The church takes its name from an outcropping of flint rock on its property. (Courtesy of the Springs Close Family Archives.)

First Baptist Church of Fort Mill is one of the area's oldest houses of worship. Today, a modern facility stands on Monroe White Street, where this original building was constructed in 1895 at a cost of $1,195. An additional expense for hanging the bell in the steeple added a full $4 to the total cost of the building. (Courtesy of the J.B. Mills Collection and Betty Mills Thomas.)

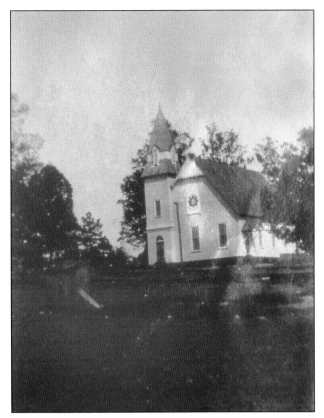

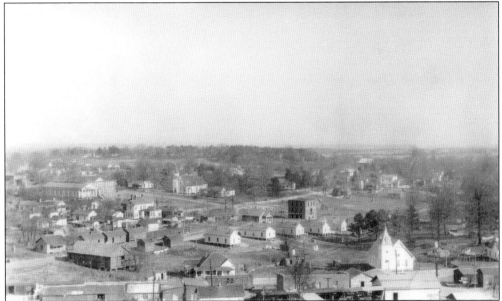

Carothers School is visible (brick building, middle left) in this aerial photograph taken in 1920. First Baptist Church (white building, middle right) stands on Monroe White Street, and St. James AME Zion church (white building, lower right) can be seen near the train tracks in a historically African American neighborhood known as Railroad Row. (Courtesy of Rufus "Rudy" Sanders.)

This photograph was taken from the grounds of Confederate Park and shows the Southern Railroad depot and the St. James AME Zion Church, which was located in the area known as Railroad Row. The predominantly African American neighborhood was home to many railroad employees, including blacksmiths, mechanics, and domestic workers. The church burned down, and the depot was demolished by the railroad company. (Courtesy of Tommy Merritt.)

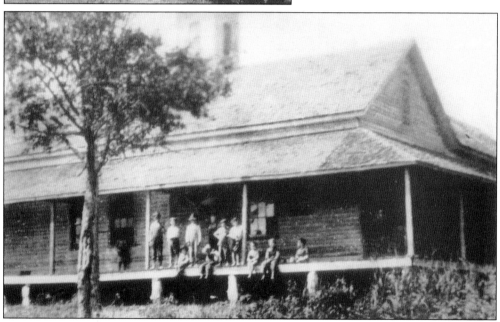

Gold Hill Academy was founded by a group of parents in 1858. There was no public school at the time and resident Charles Clawson deeded the land for $10. Parents made up the board of trustees, and students attended the school until 1935, when it merged with the publicly funded Riverview School. Gold Hill Academy then became a school for African American children. (Courtesy of Fort Mill History Museum.)

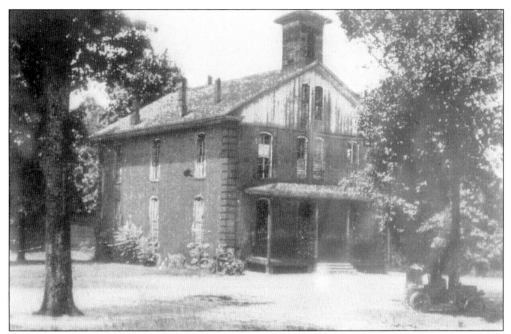

Fort Mill Academy was opened in 1871 as a private preparatory school where students could study basic subjects and Latin and Greek. Some of South Carolina's first attorneys were educated here. Tuition for a 20-week session, including languages, cost $20. Boarding was available for $9 per month. (Courtesy of the J.B. Mills Collection and Betty Mills Thomas.)

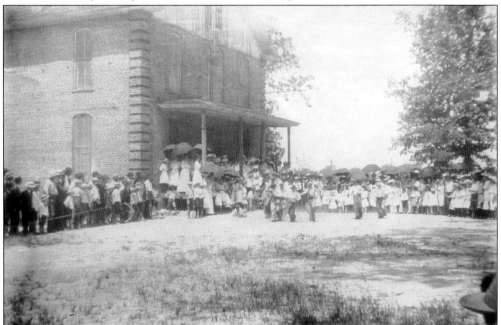

A Fourth of July celebration is shown in full swing at Fort Mill Academy in 1921. An annual picnic and barbecue was held on the grounds, and the day typically ended with a spirited baseball game. J.B. Mills remembered working at the event on this date. (Courtesy of the J.B. Mills Collection and Betty Mills Thomas.)

This humble building is the Sutton School near Lake Wylie around 1907. In the early part of the 20th century, public schools were just beginning to appear in the area. It was common for children to have only a few grades of formal education. Sutton School was eventually replaced by Riverview School. Today, Fort Mill schools are among the best in the state. (Courtesy of the J.B. Mills Collection and Betty Mills Thomas.)

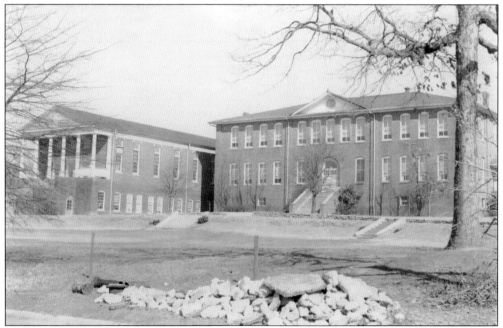

Carothers School has served many purposes over the years as a home for both elementary and upper grade students. From 1910 until 1930, students attended from grades one through ten. Initially called Fort Mill Grammar School, it was later renamed in honor of principal Lee Carothers. (Courtesy of Fort Mill High School.)

Mr. Moler poses with his 9th and 10th grade students at Carothers School in 1911. Pictured are Alex Young, Parks Boyd, Tom Hall, Shellie Sutton, Brice Culp, Joe Belk, Ruth Meacham, Mamie Jack Massey, Lila Hall, Robbie Howie, Mary Potts, Ethel Armstrong, Florence Bennett, Lula Haile, Bessie Smith, Mamie Ervin, Lucy Merritt, Lana Parks, Olive Harris, and Mae White. (Courtesy of the J.B. Mills Collection and Betty Mills Thomas.)

The graduating class of Fort Mill High School in 1916 poses proudly with their school banner. The class included A.O. Jones (front row, center), who became a teacher, principal, and namesake for a local middle school. He is also memorialized at the town's newest high school, Nation Ford. The school sits on a street that bears his name. (Courtesy of the J.B. Mills Collection and Betty Mills Thomas.)

The 1916 Fort Mill High School football team poses with its coaches. Pictured here are, from left to right, (first row) Hanks Jones, Clarence Patterson, Luther Belk, Tom Hall, and Heath "Pete" Haffner; (second row) Joe W. Nims, A.O. Jones Jr., John A. Boyd, Clarence Hoagland, Haile Ferguson, W.B. Ardrey Jr., Barron Bennett, Robert Potts, and Robert Erwin. (Courtesy of the J.B. Mills Collection and Betty Mills Thomas.)

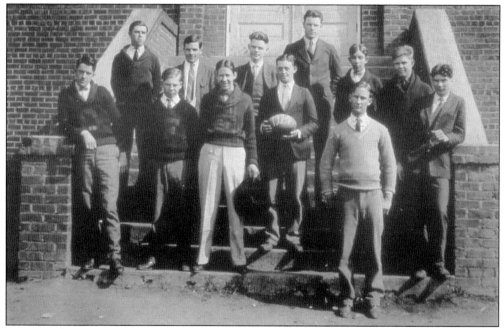

Fort Mill High School's 1924 football team poses outside the Carothers School building. Pictured are, from left to right, (first row) Paul Garrison, Eugene McKibben, J.B. Mills Jr., Luke Patterson, D.C. Patterson, and Keebler Mills; (second row) Ed Harris, Lewis Potts, Mike Link, coach Charlton Garrison, Owen Patterson, and Parks Bradford. (Courtesy of the J.B. Mills Collection and Betty Mills Thomas.)

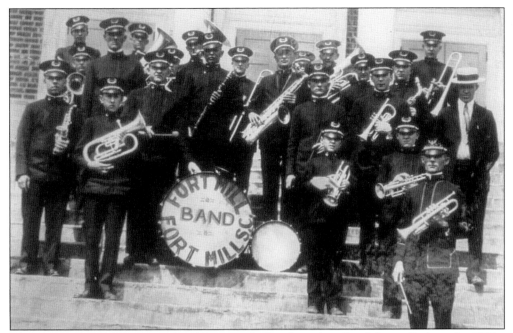

The Fort Mill Band was a regular fixture at the bandstand at Confederate Park in the 1920s. Guests from the hotels on Main Street, passengers disembarking the Southern Railroad trains, and locals alike took in live performances of lively standards from this group of area musicians. (Courtesy of the J.B. Mills Collection and Betty Mills Thomas.)

This building, located on Tom Hall Street at the site of the present-day post office, served as Fort Mill High School from 1930 until 1952. When a new building opened on Banks Street, this building was repurposed as a middle school and named in honor of A.O. Jones. Jones was a longtime educator in the area and a 1916 graduate of Fort Mill High. (Courtesy of Fort Mill High School.)

Fort Mill High School's senior class officers pose for a photograph in the 1944 yearbook. The class leadership was made up of president Sutton Epps, vice president Edward Moser, secretary Betty Joyce Buchanan, treasurer L.A. Graham, and reporters Mary Sue Hoke and Pete Patterson. (Courtesy of Fort Mill History Museum.)

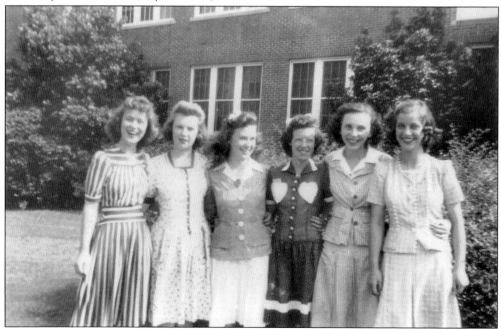

Young ladies from the senior class of 1944 pose in front of Fort Mill High School on Tom Hall Street. Pictured here are, from left to right, Catherine Bailey, Mickie Wilson, Gladys Harris, Evelyn Farris, Mary Sue Hoke, and Althea Ogburn. The photograph was taken around the time of their graduation. (Courtesy of Mary Sue Wolfe.)

The Fort Mill High School senior class proudly presented their senior play, *Mrs. Tubbs of Shantytown*, on March 30, 1945, with Juanita Whitesell in the title role. Notice the descriptive language for each character, including Mrs. Ellen Hickey, a "neighbor who knows when to keep her mouth shet [*sic*]" and Simon Rubbels, "the meanest man in Shantytown." (Courtesy of Fort Mill High School.)

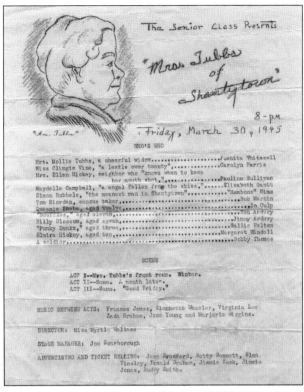

Fort Mill High School moved from the Tom Hall Street location into its new home on Banks Street in 1952. The school flourished at this location until 1986, when it moved to its current location on Munn Road. The Banks Street building was demolished in 2014. (Courtesy of Fort Mill High School.)

In 1960, Alfred Oscar Jones Jr. is pictured here in his office at Fort Mill High School on Banks Street. Born in Fort Mill in 1899, he began his education in local schools, graduating from Fort Mill High in 1916. He went on to earn degrees at Presbyterian College and the University of South Carolina. Upon his return to Fort Mill, he took his first teaching job and continued rising through the administrative ranks until his retirement in 1964. Jones was a respected teacher, principal, and superintendent during his 43-year career with the local school district. When Fort Mill High School opened a new facility on Banks Street, the previous high school building became a middle school and was renamed in his honor. He and his wife, Emma, raised two sons, Oscar A. Jones and James D. Jones. In recent years, his name was again in the news when Nation Ford High School was built on a new street bearing his name. Jones died in 1986 and was inducted into the Fort Mill Hall of Fame in 2012. (Courtesy of Fort Mill History Museum.)

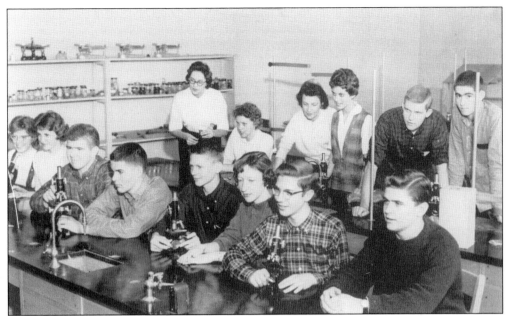

Fort Mill High's future scientists pose for a 1961 yearbook photograph. The members of the Science Club included, from left to right, (first row) Kathy Sutton, Sara Stallings, Jackie Wright, Pam Freeman, Edward Grimball, Judy Culbreth, Grady McMehan, and Harold Caudle; (second row) Linda Stallings, Betty Garland, Mrs. Harkey, Juanita Sailors, Dixon Lesslie, and Jimmy Honeycut. (Courtesy of Fort Mill History Museum.)

The Fort Mill High School class of 1988 lines up for graduation ceremonies, led by honor graduates at the head of the queue. Students in this class were only the second group to collect diplomas since the opening of the current high school facility on Munn Road in the fall of 1986. (Courtesy of Fort Mill Times.)

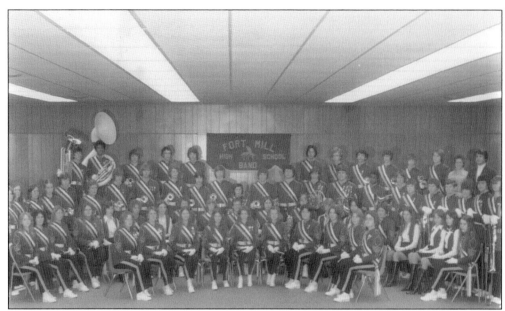

In 1949, Fort Mill High School added the first classes of what would become a powerhouse band program to its curriculum. As the program grew over the years, the band developed a reputation for spirited performances at football games and in parades. In the 1970s, director John DeLoach expanded the focus of the program to include regional and state competitions. Today, the band includes wind symphony, jazz band, and percussion ensemble elements, but it is the marching band that headlines the now-legendary program. In 1976, the group pictured above won its first state championship title. Since that time, Fort Mill High School has become the most honored band in South Carolina, with 24 state championships and hundreds of regional titles to its credit. The photograph below depicts the 1988 band in front of the White Homestead. (Both, courtesy of Fort Mill History Museum.)

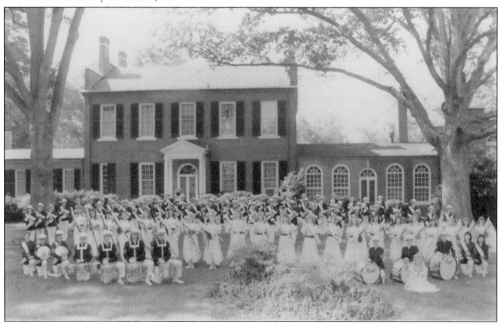

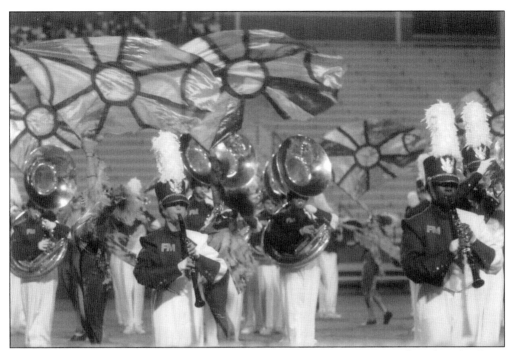

Thirty-eight years after the band brought home its first state title, Fort Mill High School was again rewarded with top honors at the division 4A championship at Spring Valley High School in Columbia, South Carolina, on October 25, 2014. The band was under the leadership of John Pruitt, director, and Ren Patel, assistant director. Clarinet and sousaphone players and members of the color guard (above) march in formation during the presentation of their competition show, *The Bells of Notre Dame*. The band poses for a group photograph (below) at its annual season-ending community performance at home, just three nights after winning its 24th state title, capping an extraordinary year. (Both, courtesy of Josh Herbert.)

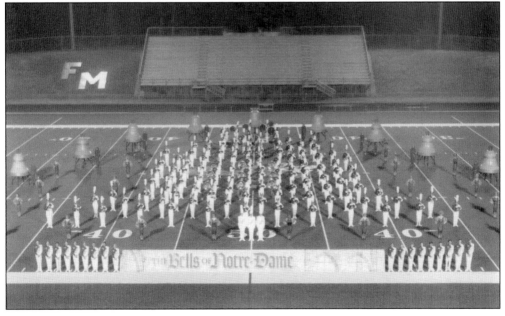

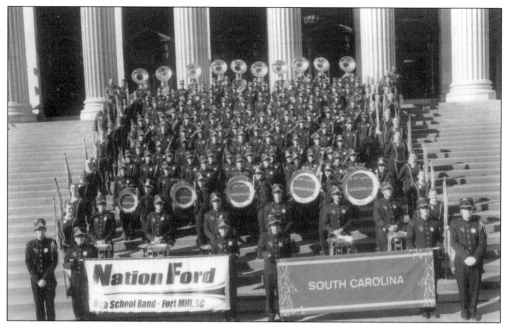

Fort Mill's tradition of excellence in high school music continues with the newest school in the district. Nation Ford High School's marching band is pictured above in New York City for the Macy's Thanksgiving Day Parade in 2011. The school opened in 2007, and the band program has garnered awards from across the region and four state championship titles since 2009. The band has been recognized with an Outstanding Performance Award by the South Carolina Band Directors Association every year since the school began competing. Member Tyler Lubben (below) plays baritone during one of the band's competition performances. (Above, courtesy of Nation Ford High School; below, courtesy of *Fort Mill Times*.)

Six

LIFE IN PARADISE
THE AFRICAN AMERICAN
EXPERIENCE IN FORT MILL

For small towns in the South, race has always been a defining issue. In a place where so much Civil War history is prevalent, one might expect a divisive culture, and Fort Mill did not sail through the past two centuries without blemish in the area of civil rights. But the people of the town have come together in ways that defy the stereotype that is pervasive in this region of the country. From Solomon Spratt's selfless acts of kindness during the War Between the States to George Fish's call for equal schools to the cohesive community called Paradise, Fort Mill has borne the struggles of inequality and emerged as a place that is welcoming and inclusive. Rufus Sanders, who has lived all over the world in the service of the US military, described his hometown best when he said, "If I had to grow up all over again in the same circumstances, give me Fort Mill, South Carolina."

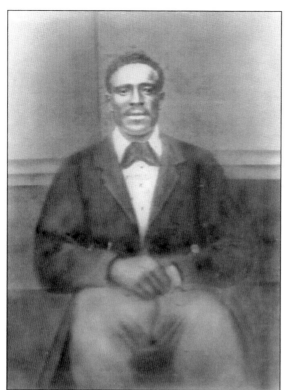

Solomon Spratt (1839–1894) was a slave on the plantation of Thomas Dryden Spratt. During the Civil War, he led a group of slaves in an endeavor to care for women and children left behind when the men went to the front lines. The efforts of this group kept families fed and farms running. He is memorialized on the "Faithful Slaves" monument in Confederate Park. (Courtesy of Fort Mill History Museum.)

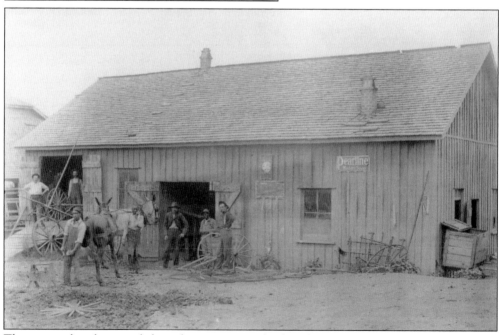

The men in this photograph from the 1890s were wheelwrights and laborers. Since the end of the Civil War, newly freed black men were working for wages alongside white men for the first time. Black workers found employment in many trades, including jobs with the railroad as mechanics and blacksmiths. (Courtesy of Fort Mill History Museum.)

Bride Anne Springs Close greets family friend Lillie Phifer on May 15, 1958. Phifer's mother, Lucy, had been a slave and later worked in service for the Allison family before emigrating with her husband and children to Liberia. The family suffered great tragedy as a result of tropical fever, and Lucy's postwar employers financed the return of the surviving family members to the United States. Later, the Springs family provided her with a job and a home on family property, where she raised Lillie and one surviving son. (Courtesy of the Springs Close Family Archives.)

Lucy Phifer was born a slave in 1844. She emigrated with her family to Liberia in 1882, where her husband and two daughters succumbed to tropical fever. She appealed to her postwar employers and returned home, along with a son and daughter, Lillie. Lucy worked at the White Homestead and lived in a cottage on Springs property and, later, in the Paradise section of town on what was then called African Street. She died in 1930. (Courtesy of Rufus "Rudy" Sanders.)

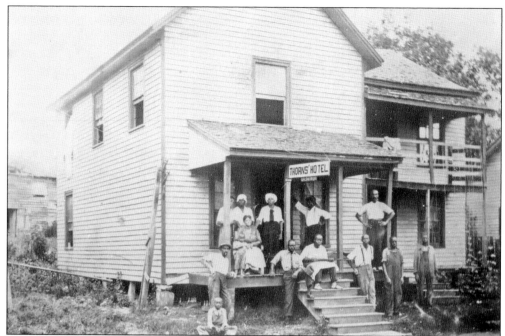

In the first half of the 20th century, travelers to Fort Mill had their choice of lodgings near the rail depot, but most of the options were limited to white customers. Thorns Hotel on Academy Street was reserved for black customers. The two-story structure is shown here with guests in the 1920s. (Courtesy of the Springs Close Family Archives.)

Cotton cultivation continued to drive the economy in postwar Fort Mill. Both large-scale planters and small farmers alike grew the cash crop, and it took many hands to harvest and prepare it for market. This photograph captures workers in a small patch of cotton on a local farm. (Courtesy of the J.B. Mills Collection and Betty Mills Thomas.)

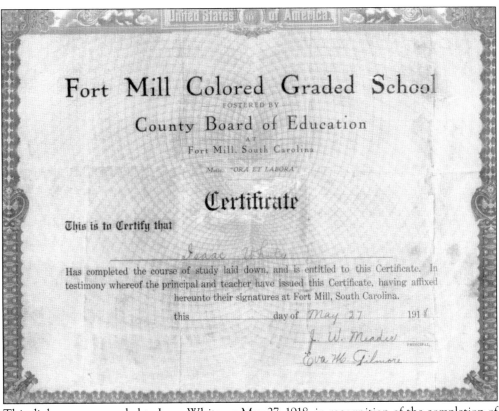

This diploma was awarded to Isaac White on May 27, 1918, in recognition of the completion of his education at the Fort Mill Colored Graded School. The school was referred to as the "old Academy," as it had been passed down from its original use as a private preparatory school, to a public school, and, finally, to a school for black children. (Courtesy of Rufus "Rudy" Sanders.)

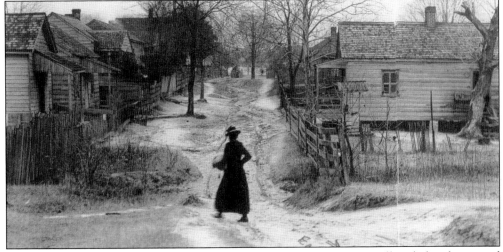

Before the growth of the Paradise community, African Americans typically inhabited scattered neighborhoods around town, including Maybee Hollow (above). The woman in the photograph is walking on Elliott Street around 1930. These neighborhoods disappeared in the 1950s as residents moved to newer homes in the Paradise area. (Courtesy of Rufus "Rudy" Sanders.)

Irene Barnes Patterson (1903–1973) worked as a maid and cook for the family of Elliott White Springs. She was a firm believer in education and, along with her husband, Willie, saw all six of her children earn college degrees. The children established a scholarship in her name at Bennett College in Greensboro, North Carolina. (Courtesy of Ken Dixon and Elizabeth Patterson White.)

Willie Patterson (1897–1973) filled a variety of roles for Elliott White Springs. He was butler, bodyguard, chauffeur, and aviation contact man for Colonel Springs. In fact, Springs trained Patterson as a pilot, but he was unable to obtain an official pilot's license because African Americans were not licensed by the state. (Courtesy of Ken Dixon and Elizabeth Patterson White.)

Elizabeth "Libby" Patterson (above) was the first African American woman in South Carolina to be licensed to drive a school bus. Even more extraordinary was her age at the time. After earning her regular license at age 14, she received her bus license in 1957 (below) when she was a sophomore in high school and drove until she graduated in 1959. She had learned to drive in the field that served as an airport next to the White Homestead, where her parents worked for the Springs Family. At the time of her employment, bus drivers in York County were paid $40 per month. Col. Elliott White Springs supplemented the income of drivers in Fort Mill, and they were paid double. Patterson went on to graduate college and earn two master's degrees. (Both, courtesy of Ken Dixon and Elizabeth Patterson White.)

SCHOOL BUS DRIVER'S CERTIFICATE SCHD 469

RACE	SEX	ADULT	STUDENT		CERTIFICATE NO.	DR. LICENSE NO.
C	F		X		C29991	1142713

DATE OF BIRTH	COUNTY SUPERINTENDENT
10-16-41	Lee Sherer

THIS IS TO CERTIFY THAT, PURSUANT TO THE PROVISIONS OF SECTION 21-839 OF THE 1952 CODE OF LAWS OF SOUTH CAROLINA

NAME: Elizabeth Ann Patterson

ADDRESS: 102 Smith Street
Fort Mill, S. C.

satisfactorily completed a training course for school bus drivers, has been examined by the South Carolina State Highway Department, and is qualified to operate a school bus in the State of South Carolina. This privilege is contingent upon the possession of a valid driver's license and is subject to suspension, as provided by law.

WHERE TRAINED:	PERIOD OF TRAINING:
Finley High - Chester	Oct. 14-16, 1957

DRIVER'S SCHOOL:	ADDRESS:	COUNTY:
George Fish High	Fort Mill	York

10-18-57

C. P. McMillan

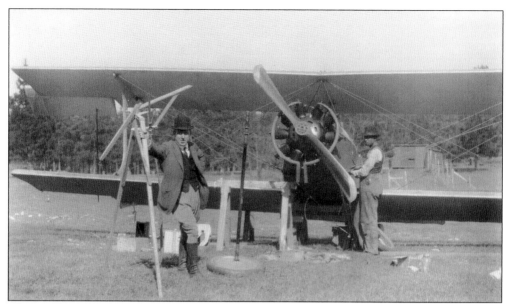

Elliott White Springs is pictured here with his plane and his contact man Willie Patterson. Patterson served various roles in the Colonel's employ, including chauffeur, but his most well known may have been in this role as the official "cranker-upper" of the plane's propeller prior to flight. (Courtesy of the Springs Close Family Archives.)

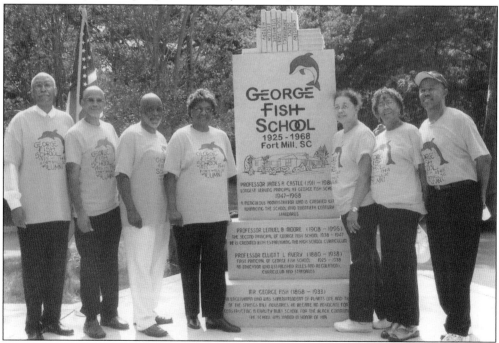

Though the George Fish School is no longer in existence, a group of alumni came together in 2007 to erect a monument on the site. The committee is pictured here; from left to right are Rev. Phillip Cargile Sr., Rufus Sanders, Osby Watts, Naomi Gilmore Stanley, Elizabeth Patterson White, Ruth Patterson Meachum, and John Sanders III. (Courtesy of Ken Dixon and Elizabeth Patterson White.)

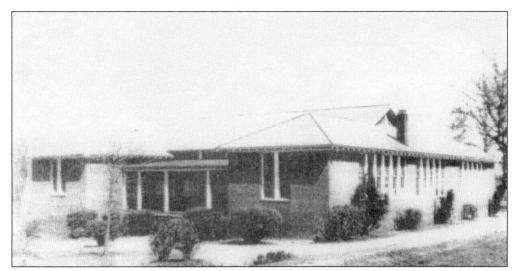

The George Fish School (above) opened on Steele Street in 1924. Several generations of African American students attended the school prior to integration. It was named in honor of a British plant manager at the town mill. George Fish (right) was a vocal proponent of equality in education and led the effort to build a quality, all-brick school similar to those available for white children. It was built in the area of town known as Paradise. The last senior class graduated in 1968, and the building temporarily became a junior high school before being demolished in the 1980s. (Both, courtesy of Rufus "Rudy" Sanders.)

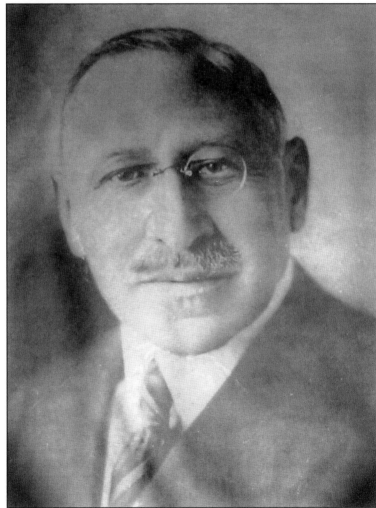

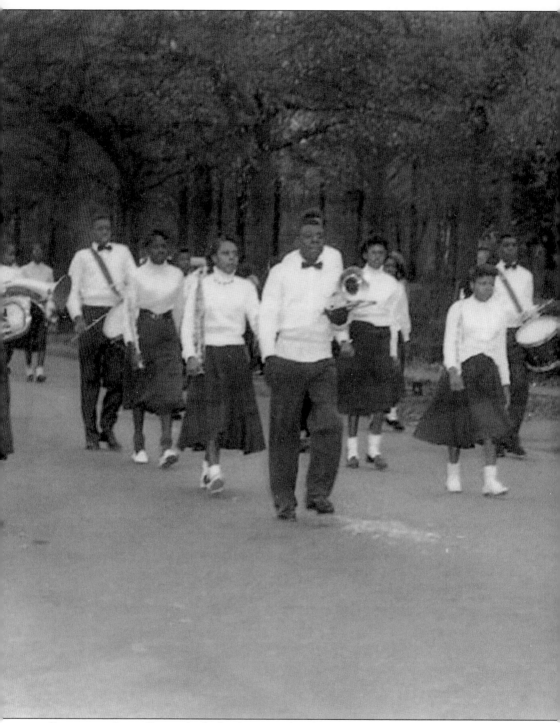

Drum major James Barrett leads the George Fish School Band in the Fort Mill Christmas parade in December 1953. The program had been recently formed under the direction of Bobby S. Plair. The band did not have uniforms, so Plair asked parents to outfit the students in black and white, including bow ties for the young men. The drum major was outfitted in the reverse color scheme

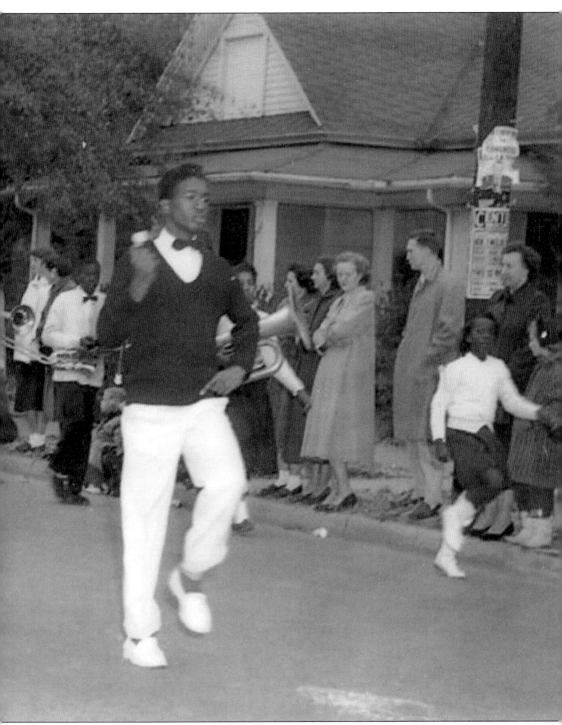

with white pants and black shirt. The following year, the school received a set of hand-me-down uniforms when the band at Fort Mill High School replaced their own and donated the used ones to Fish. (Courtesy of Rufus "Rudy" Sanders.)

John Lester Sanders Jr., or "Shine" as he was known about town, was born in 1914 and is remembered as a pioneer of the Paradise community. He acquired his nickname when he took on his first job shining shoes on Main Street. Shine opened Sanders Grocery Store in the early 1950s, and he was known as a man of integrity and a strong supporter of the people of his community. Sanders was always willing to lend a hand, be it for the Boy Scouts at Bethlehem Baptist Church or school groups from the George Fish School. He was a role model for young African Americans in Fort Mill with his advocacy during the civil rights era and a devoted father to eight children. Five of his children served in the armed forces, further demonstrating the strong values of commitment and service they learned in his home. Sanders died at the age of 90 in 2004. (Courtesy of Rufus "Rudy" Sanders.)

The George Fish School class of 1959 poses for a group photograph. Pictured here are, from left to right, (first row) James Kaiser, Thomas Perry, Willie Culp, and Calvin Wallace; (second row) Doris Boulware, Mary Ethel Williams, Elizabeth Patterson, Mary Lee Rutledge, Rosetta Rutledge, Elizabeth Kaiser, Myrtle Howie, and Dorothy Boulware. (Courtesy of Ken Dixon and Elizabeth Patterson White.)

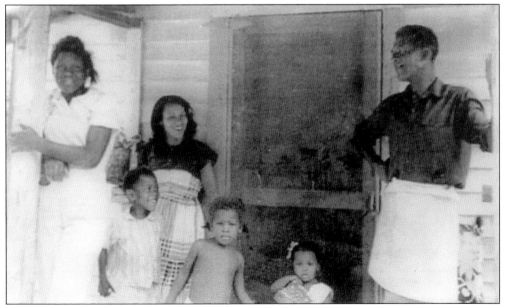

Gretchen Moore (left), Ailene Wilson (center) and her children, and Robert Sutton share an afternoon on the porch of a Smith Street home in the Paradise section of town in 1953. Moore became a teacher at George Fish School, and Robert Sutton (formerly a resident of Maybee Hollow) played piano at Bethlehem Baptist Church. (Courtesy of Rufus "Rudy" Sanders.)

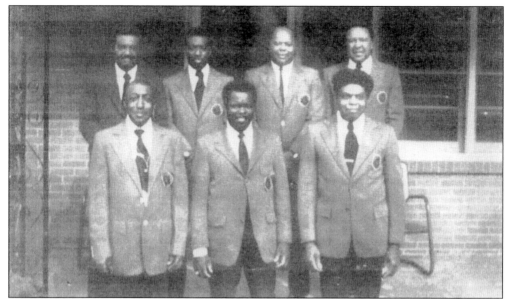

Members of the Community Concern Men's Club pose at their meeting in the 1970s. Residents of the Paradise and Pine Ridge communities looked to the group to address social and political matters. Pictured here are, from left to right, (first row) Rev. James D. Dunlap, Daniel Watts, and Albert White; (second row) John T. Miller, Willie L. Culp, James W. Kirkpatrick, and Charlie Kirkpatrick. (Courtesy of Cora Lyles.)

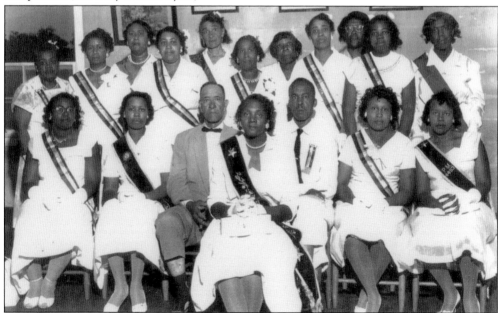

The Order of the Eastern Star, chapter No. 124, gathers in 1954. Pictured here are, from left to right, (center front) Jeanette Kiser; (first row) Anna Potts Dixon, Ella White Potts, John Samuel Sanders Sr., Simon A. White Jr., Mildred Faulkner Miller, and Addie Faulkner White; (second row) Mary Elizabeth Perry, unidentified, Maggie Lean Dunlap Brice, Irene Patterson, Rinda Spratt Graham, Ethel Davis, Anna Watts-White, Doretha Gilmore, unidentified, Ella Dixon, and Hattie Culp. (Courtesy of Cora Lyles.)

Seven

LIVING HERE
THE PEOPLE AND PLACES OF FORT MILL

For generations, living in Fort Mill has meant the best of both worlds—the convenience of nearby city amenities and the comforts of small-town life. Whether at work or at play, the people of the area have always found creative ways to spend their time. The character of a place is often displayed in the way its people live. The homes, social groups, recreation activities, and pastimes of the people of Fort Mill display a wide variety of interests and more than a few quirks. Though time marches on and habits change, much of what was enjoyable 100 years ago is still enjoyable today. One still sees cyclists on the road, swimmers in the lake, and automobile enthusiasts displaying their shiny toys. Fort Mill has been, and always will be, a place where life can be experienced to the fullest.

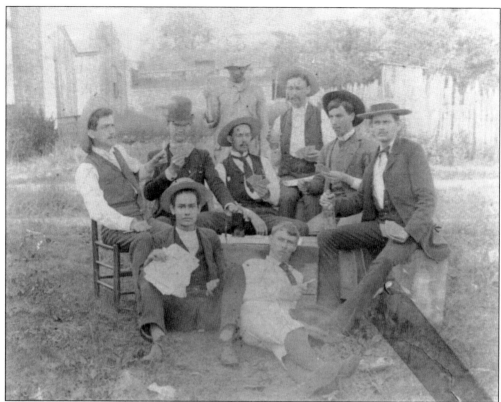

The group of young men pictured here in 1885 were merchants and bachelors, which may have led to the name they chose for their group: the Young Men's Courting Association. Members were, from left to right, (first row) Joe Drakeford and Bob Irwin; (second row) Al Mack, Barron Mills, Will Watson, McKeever Hughes, Banks Meacham, and W.B. Meacham. (Courtesy of the Springs Close Family Archives.)

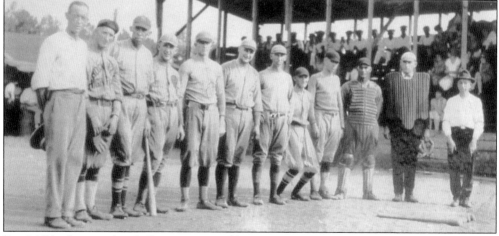

Fort Mill had its own baseball team, pictured here in 1925. Allie Ferguson (far left) managed the team, and R.P. "Bob" Reeves (far right) was its official scorekeeper. All the names are not known, but it is reported that the third baseman bore the moniker "Whacker" Smith. (Courtesy of the J.B. Mills Collection and Betty Mills Thomas.)

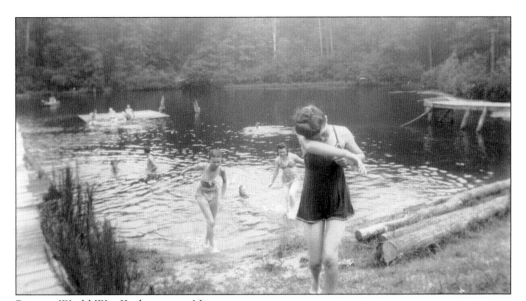

Prior to World War II, the area at Nims Lake was a hot spot for people looking for recreation. Located near Doby's Bridge Road, the area boasted a two-sided bathhouse, springboards, a two-level tower, and a dance pavilion. Property owner Fred Nims Sr. developed the man made lake from what had been a low-lying rice field. The attraction had the feel of a resort, with people traveling from miles around to enjoy the amenities. After the war, with the increased focus on long-distance automobile trips, interest in the area declined in favor of bigger and flashier venues. These photographs show an unidentified girl in a swimsuit of the period (right) on the lake's dock and a group of girls leaving the water near the bathhouse. (Both, courtesy of Fort Mill History Museum.)

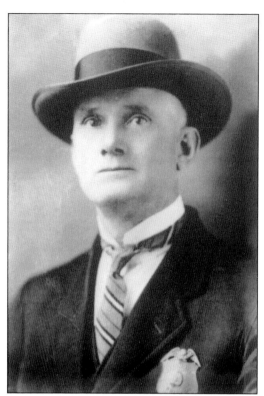

Van Dawson Potts (1876–1955) was police chief in Fort Mill for 24 years. He was known about town as a colorful character and an excellent lawman who kept order at a time when bootlegging and vigilante justice were prevalent. His law enforcement career spanned 36 years and included service in the Rock Hill area. He is buried in Unity Cemetery. (Courtesy of Fort Mill History Museum.)

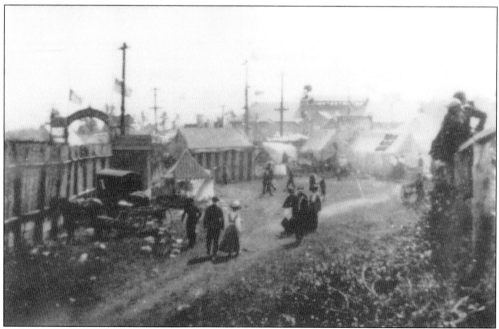

The circus came to Fort Mill in the 1890s. This photograph appears to be of the fairway at the event. It may have been held in the area at the top of the hill on Main Street. Events such as this were always held in the fall after the harvest, when people had money to spend. (Courtesy of the Springs Close Family Archives.)

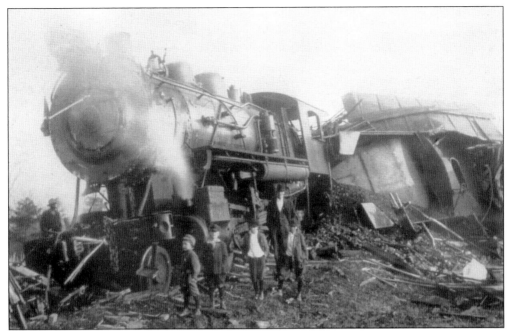

Curiosity-seekers get up close and personal with this derailed Southern Railroad express train. The train, en route from Washington, DC, to Atlanta, Georgia, jumped the tracks two miles north of town on December 15, 1921. The passenger train, No. 31, did not normally stop in Fort Mill. There were no injuries. (Courtesy of the J.B. Mills Collection and Betty Mills Thomas.)

A group of young people gathers in their finest Victorian attire for an outing of cycling in 1893. The photograph was taken in front of Alma Barber's house on Confederate Street. W.B. Ardrey Sr. is the man in the white shirt at the center of the photograph. (Courtesy of the Springs Close Family Archives.)

The Addie Harris house (foreground) sits near the railroad tracks in 1908. This view is facing westward with White Street behind the house and Massey Street going up the hill. The immediate foreground includes the banked earth of the railroad cut. (Courtesy of the J.B. Mills Collection and Betty Mills Thomas.)

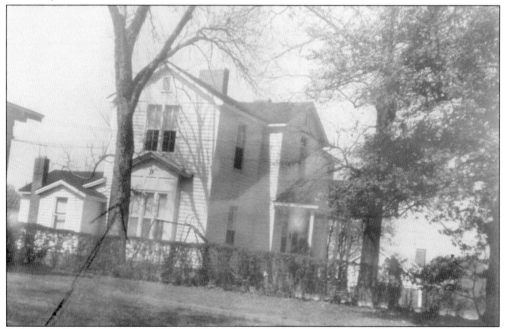

The house in this photograph was known about town as the doctor's house, as it was home to a series of physicians, including T.S. Kirkpatrick, T.B. Meacham, T.B. Kell, Dr. Waddell, and J.M. Ott, a dentist. Dr. Meacham died in the house in October 1908. (Courtesy of the J.B. Mills Collection and Betty Mills Thomas.)

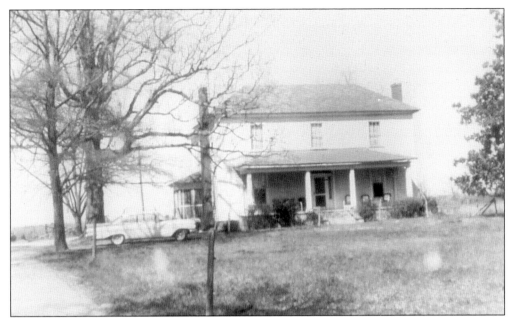

This house, known as the Old Squire Bailes Home, was built on the line separating North and South Carolina. Rooms on the left side of the home's central hallway were in South Carolina, with North Carolina claiming the rooms on the right. Couples from both states came to the house to be married. The home is pictured here in 1966. (Courtesy of the J.B. Mills Collection and Betty Mills Thomas.)

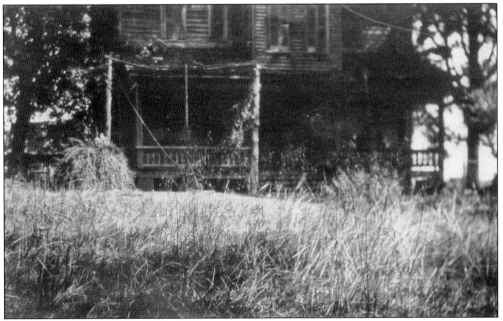

This is the old Spratt House, which was located south of town on Brickyard Road. The site is relatively close to the Catawba River, where Thomas Spratt first encountered the Catawba Indians and became the first white settler of Fort Mill. The house was built in 1810 and demolished in 1957. (Courtesy of the J.B. Mills Collection and Betty Mills Thomas.)

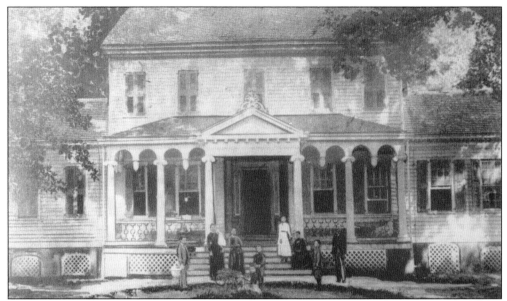

In the early 1890s, the family of Springfield Plantation manager David A. Lee lived in the main house for a time. The Lee family is pictured here; from left to right are James H. Lee, Sarah Elizabeth Lee, Thomas K. Lee (infant), Mary Lane Lee, Robert G. Lee (with wagon), Frank Lee, Frances Lee, Mollie Clark, Ben M. Lee, and David A. Lee. (Courtesy of the Springs Close Family Archives.)

The building pictured here was a social clubhouse that dates to 1905. A local military unit owned the building but allowed use of it to other groups. It was located south of town near the Catawba River in Spratt's Bottom. The building was destroyed by the flood of 1916. (Courtesy of the J.B. Mills Collection and Betty Mills Thomas.)

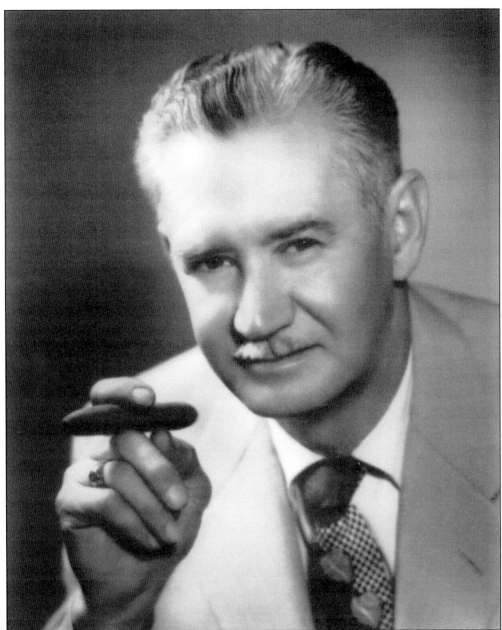

John Barron Mills Jr., born in 1906 and known as J.B., was a native of Fort Mill, a business owner, avid golfer, and dedicated historian around town. After attending Presbyterian College, he returned to his hometown and opened Mills Self-Service store on Main Street in 1928. The store carried grocery items at the time, but he later enlarged the scope of the business to include hardware and changed the name to Mills Hardware, where he operated until a 1947 fire destroyed the store. He reopened on White Street. Mills raised a family on nearby Confederate Street, served on the town council and the school board, and became one of Fort Mill's foremost historians. His collection of photographs and anecdotes from the early 20th century has brought town history to life for thousands. He died in 1993 and was inducted into the Fort Mill Hall of Fame in 2012. (Courtesy of Fort Mill History Museum.)

William R. Bradford Jr. was perhaps the best historian Fort Mill has ever had. He published a thorough history book titled *Out of the Past* in 1980 and continued to update the text every few years until 2008. This book serves as the single most comprehensive resource for research about the town. Bradford was both publisher and editor of the *Fort Mill Times* from 1943 until 1979. He was also well known as the voice of the Yellow Jackets, providing play-by-play announcements for Fort Mill High's football team from 1954 until 1968. Bradford served the town in a political capacity as York County magistrate from 1982 until 1987. He received both Lifetime Service Awards and Citizen of the Year awards from local agencies. He died in 2013 at the age of 97. (Courtesy of Fort Mill History Museum.)

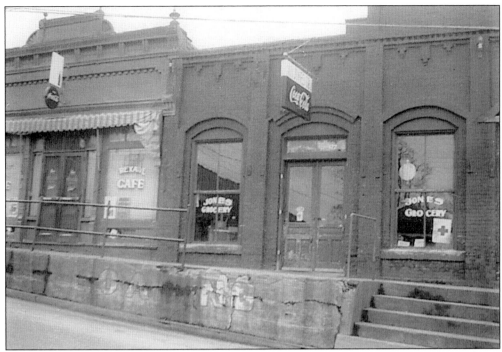

This photograph captures Rexall Café, A.O. Jones Grocery Store, and the edge of Carothers's barbershop. The Rexall Café was later turned into a popular pool hall that drew great crowds for socializing on Main Street. (Courtesy of Tommy Merritt.)

This automobile was the first one in Fort Mill Township. It is a 1906 Reo and was bought secondhand by C.H. Branson. He is pictured here in the driver's seat accompanied by passengers W.B. Meacham (front left), R.P. Harris, and S.L. Meacham. (Courtesy of the J.B. Mills Collection and Betty Mills Thomas.)

In 1916, a tremendous storm hit Fort Mill as the result of the convergence of two category 4 hurricanes. Over a three-day period from July 14 to 16, floodwaters rose at an alarming rate, ultimately overflowing the riverbanks and completely washing out the Southern Railroad Bridge at the Nation Ford. The storm also caused flooding in North Carolina's French Broad River, and 13 railroad workers were killed when an engine parked on a bridge between Mecklenburg and Gaston Counties was swept away. High water completely covered the Catawba Power Company's dam (above left) and destroyed the powerhouse. As the waters receded, onlookers walked the tracks to the edge of the river (below) to view the damage. (Both, courtesy of the J.B. Mills Collection and Betty Mills Thomas.)

When the 1916 flood washed out the railroad bridge over the Catawba River, the tracks and steel support structures fell into the water (above), but the granite pillars used to build the trestle remained (below). New England brothers Frederick and Horace Nims were contracted to build the trestle, which was completed in 1852. They purchased a nearby granite quarry and methodically cut and stacked the stones for maximum strength. Their excellent workmanship paid off, as the pillars withstood the impact of the violent waters. The trestle was added to the National Register of Historic Places in 2000. (Both, courtesy of the J.B. Mills Collection and Betty Mills Thomas.)

Elliott White Springs excites the crowd with an under-bridge pass at the dedication ceremony for the Buster Boyd Bridge over Lake Wylie on August 17, 1923. The plane was a Morse Fighter with a single seat. Fellow pilot Paul Redfern made similar maneuvers under the bridge during the ceremony. (Courtesy of the J.B. Mills Collection and Betty Mills Thomas.)

In the early 20th century, A.A. Young's shop was a popular landmark in Fort Mill. On this day in 1910, a large crane was added to the collection of attractions that drew people to visit. The men and boys in the photograph are unidentified. (Courtesy of the J.B. Mills Collection and Betty Mills Thomas.)

Samuel E. White loved spending time on the whittling porch in Fort Mill, swapping stories with fellow Confederate veterans. After the death of his wife, he moved to Lancaster to live with family. His son-in-law, Leroy Springs, put up this tent in Lancaster to provide a place where the men could congregate and pass the time whittling and spinning tales. (Courtesy of the Springs Close Family Archives.)

The officers of Catawba Lodge No. 56 pose for a group photograph in 1890. The Freemason lodge was established in 1858. Pictured here are, from left to right, (first row) J.C. Young, W.E. Spratt, J.W. Ardrey, W.B. Meacham, and J.M. Spratt; (second row) J.M. Armstrong, J.D. Withers, J.L. Kimbrell, W.E. Sledge, and W.W. Warren. (Courtesy of the J.B. Mills Collection and Betty Mills Thomas.)

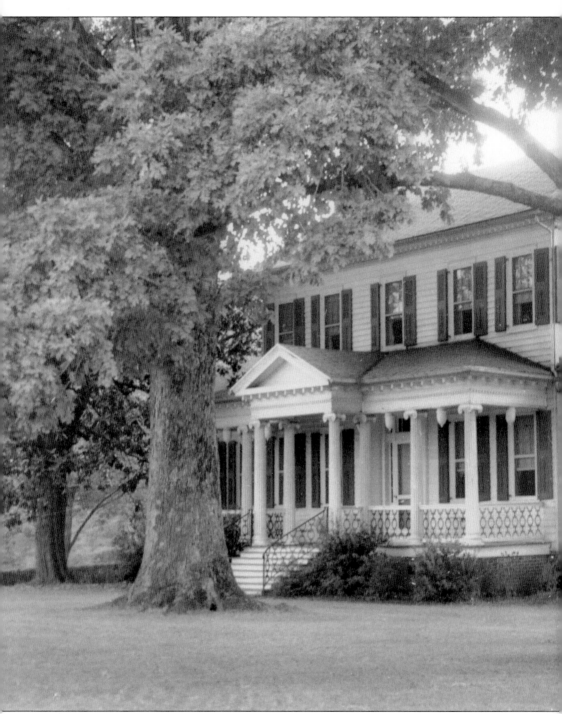

Springfield Plantation House was constructed between the years 1790 and 1806 for John Springs III. His descendant and signer of the Ordinance of Secession, Andrew Baxter Springs, owned the home during the Civil War and hosted the Confederate Cabinet on their flight from Richmond, Virginia. Springs recommended the members split up to avoid capture by Union troops. After spending a night here, the cabinet met for a final time at the nearby White Homestead. Elliott

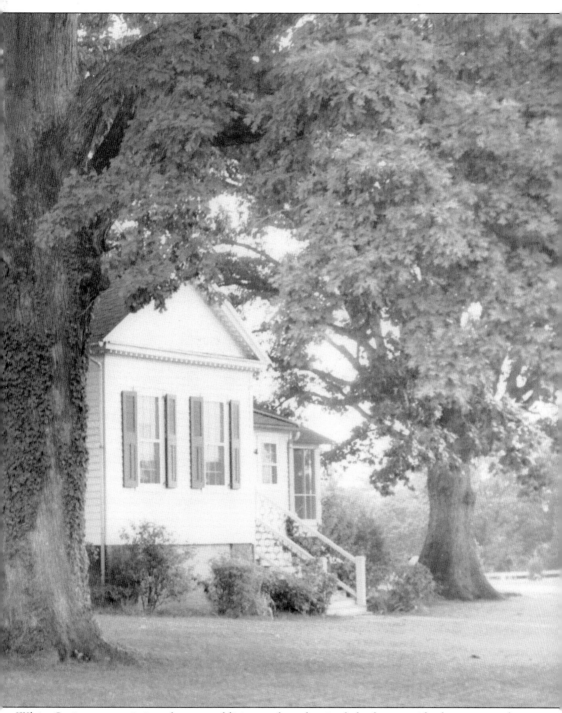

White Springs commissioned a rear addition and modernized the home with electricity and plumbing in 1946. The structure is believed to the oldest wood-frame house in Fort Mill and has been owned by members of the Springs family since its construction more than 200 years ago. It was added to the National Register on September 12, 1985. (Courtesy of the Springs Close Family Archives.)

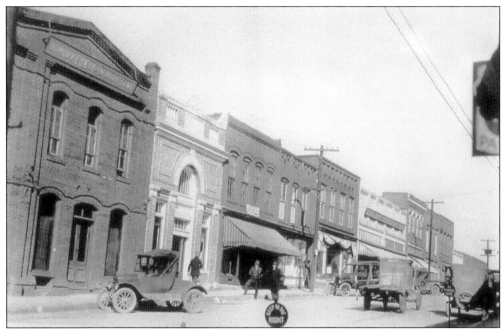

This image of Main Street dates to 1930. The building on the far left is the armory for Company K, part of the 118th Infantry, and the building beside it with the white arch is the Spratt building. Most of the buildings in this photograph, with the exception of the armory, still exist today. (Courtesy of the J.B. Mills Collection and Betty Mills Thomas.)

Main Street wears celebratory bunting to commemorate the town's centennial on July 4, 1983. Confederate Park and the bandstand are at left. Early town residents would have missed the whittling porch on the old town hall if they had been present at the celebration. The popular gathering spot had burned years earlier. (Courtesy of the J.B. Mills Collection and Betty Mills Thomas.)

ABOUT THE ORGANIZATIONS

Special thanks go to the following organizations:

Springs Close Family Archives and Special Collections was established in 1991 to preserve and catalog the historical documents, antiques, and fine arts collections pertaining to the history of the White, Springs, and Close families, Springs Industries, and the surrounding communities. Housed within the White Homestead, the records date from 1764 to the present and include over 200 linear feet of records and more than 2,000 bound volumes. The collection is open to researchers by appointment. (Courtesy of the Springs Close Family Archives.)

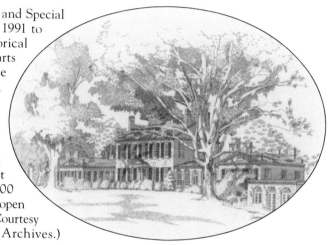

The Fort Mill History Museum's mission is to play a leading role in the collection, preservation, and promotion of the history of Fort Mill and the surrounding area. The museum strives to be an accessible resource, actively encouraging the discovery, appreciation, understanding, and enjoyment of the community's past for the benefit of present and future generations. To fulfill this mission, the museum continues to build its collections through purchase and gifts and develops programs of exhibitions, publications, scholarly research, public education, and the arts that engage our diverse local communities. (Courtesy of Fort Mill History Museum.)

DISCOVER THOUSANDS OF LOCAL HISTORY BOOKS
FEATURING MILLIONS OF VINTAGE IMAGES

Arcadia Publishing, the leading local history publisher in the United States, is committed to making history accessible and meaningful through publishing books that celebrate and preserve the heritage of America's people and places.

Find more books like this at
www.arcadiapublishing.com

Search for your hometown history, your old stomping grounds, and even your favorite sports team.